VATICAN
TREASURES

AN EXHIBITION IN
HONOR OF THE
SESQUICENTENARY
OF THE DIOCESE OF
CLEVELAND

VATICAN TREASURES

EARLY CHRISTIAN,
RENAISSANCE,
AND BAROQUE ART
FROM THE
PAPAL COLLECTIONS

Robert P. Bergman

Diane De Grazia

with contributions by

Stephen N. Fliegel

THE CLEVELAND MUSEUM OF ART

Published on the occasion of the exhibition *Vatican Treasures: Early Christian, Renaissance, and Baroque Art from the Papal Collections*, 8 February–12 April 1998, organized by the Cleveland Museum of Art.

Major support for the exhibition and catalogue is provided by the F. J. O'Neill Charitable Corporation in special recognition of the 150th Anniversary of the Diocese of Cleveland. Additional funding is provided by The Illuminating Company, a FirstEnergy Company. The exhibition is supported by an indemnity from the Federal Council on the Arts and the Humanities.

First published in the United States in 1998.

Covers: *The Cross of Justin II*

Editing: Barbara J. Bradley and Kathleen Mills
Design: Thomas H. Barnard III, papal escutcheons by Carolyn K. Lewis
Production: Charles Szabla
Printed on Vintage Velvet 100-pound text by Great Lakes Lithograph
Composed in Adobe Aldus Roman with Adobe PC Pagemaker 6.0

Photography credits: All photographic material is courtesy the Vatican Museums, except p. 104 (courtesy Art Resource); the following photographer is acknowledged: P. Zigrossi (p. 96).

LIBRARY OF CONGRESS CATALOGING-IN-PUBLICATION DATA

Bergman, Robert P., 1945–
 Vatican treasures : early Christian, Renaissance, and baroque art from the papal collections : an exhibition in honor of the sesquicentenary of the Diocese of Cleveland / Robert P. Bergman, Diane De Grazia, with contributions by Stephen N. Fliegel.
 p. cm.
 Exhibition dates: Feb. 8 through April 12, 1998.
 ISBN 0–940717–44–1 (hardcover : alk. paper). —ISBN 0–940717–45–X (pbk. : alk. paper)
 1. Art—Vatican City—Exhibitions. 2. Vatican Palace (Vatican City)—Exhibitions. I. DeGrazia, Diane, 1943– . II. Fliegel, Stephen N., 1950– . III. Catholic Church. Diocese of Cleveland (Ohio). IV. Cleveland Museum of Art. V. Title
N2940.B47 1998
708.56'34'07477132—dc21 97–38598
 CIP

Dimensions, as supplied by lenders, are given in centimeters (and inches), height by width by depth or height by diameter. Works are arranged chronologically within each section.

∞ The paper used in this publication meets the minimum requirements of the American National Standard for Information Services—Permanence of Paper of Printed Library Materials, ANSI Z3948–1984.

CONTENTS

One hundred and fifty years after Pope Pius IX sent the Most Reverend Louis Amadeus Rappe to evangelize and shepherd the area that is now the Diocese of Cleveland, numerous events are being held to commemorate the sesquicentennial anniversary of the establishment of the Diocese. The Holy See is happy to share in Cleveland's joy through the exhibition *Vatican Treasures: Early Christian, Renaissance, and Baroque Art from the Papal Collections.*

It is my sincere hope that through this exhibition the people of Northeast Ohio will be able to appreciate firsthand some of the masterpieces that embody the artistic and religious heritage of the Christian world, and that are part of the cultural heritage of humanity. These works of genuine religious art testify to the artists' desire to express their faith in God through the talents that He himself had given them. They illustrate the ageless dialogue between the message of the Gospel and its cultural expression. They invite all who come to view these works to raise their minds and hearts in thanksgiving to the Creator who enables us to perceive the infinite interior harmony of His existence in the beauty of the universe and in the beauty of human creativity.

In the name of His Holiness Pope John Paul II, I express gratitude to the Cleveland Museum of Art and to its director, Dr. Robert P. Bergman, for his initiative and cooperation with the Diocese of Cleveland. His Holiness sends warm greetings to the Most Reverend Anthony M. Pilla, ninth Bishop of Cleveland, and to all who have assisted in preparing this special event. May it inspire others to cultivate the noblest aspirations of the human heart. Upon all the visitors to the exhibition he invokes abundant divine blessings of joy and peace.

+ Angelo Card. Sodano

Angelo Cardinal Sodano
Secretary of State of His Holiness

From the Vatican, 27 December 1997, Feast of St. John the Evangelist

Dear Friends:

Down through the centuries, art and religion have been deeply entwined. Many of our greatest artworks also have great spiritual significance. The Roman Catholic Church has assembled one of the most important collections of Christian liturgical art on Earth. Unfortunately, until now only a relative few who could travel to the Vatican had any chance to view these enlightening masterpieces.

The Diocese of Cleveland is honored that one of the world's great museums, the Cleveland Museum of Art, is presenting *Vatican Treasures: Early Christian, Renaissance, and Baroque Art from the Papal Collections* and that its director, Dr. Robert P. Bergman, has fostered this collaboration between the museum, the Vatican, and the Catholic Diocese of Cleveland.

This truly inspired exhibit has been produced in celebration of the sesquicentennial of the Diocese of Cleveland. Since 1847, the Diocese has played an important role in shaping this great community. How appropriate that the internationally renowned Cleveland Museum of Art should assemble and host such an extraordinary exhibition to mark this anniversary.

Dr. Bergman and the museum's chief curator, Dr. Diane De Grazia, are serving as curators of *Vatican Treasures*, which spans roughly 1,000 years of liturgical art and reflects a broad range of styles and influences as interpreted by some of the greatest artists of their time. Many of these masterpieces are on public display outside the Vatican collections for the very first time. This extraordinary exhibit offers a once-in-a-lifetime opportunity for patrons of the arts here in Northeast Ohio to view some of the most precious Vatican artworks.

I wish to express my deep appreciation to the F. J. O'Neill Charitable Corporation, which provided underwriting sponsorship for this exhibit in special recognition of the 150th anniversary of the Diocese of Cleveland, and to Dr. Bergman and the Cleveland Museum of Art.

Sincerely,

Most Reverend Anthony M. Pilla
Bishop of Cleveland

PREFACE

VATICAN TREASURES has come to fruition as a result of a team effort
and spirit of cooperation encompassing colleagues in the Vatican, the
Diocese of Cleveland, the Cleveland Museum of Art, and the Cleveland
community. In this instance, two years of planning was aided by the col-
laboration of countless friends and associates in Rome and Cleveland. It
is my humble belief that the audacity of those of us at the museum could
never have yielded positive results without the sanctity of our clerical
partners—and vice versa. The enterprise was an ideal partnership and col-
laboration.

When the Diocese of Cleveland began planning the celebration of its
sesquicentenary, representatives of Bishop Anthony Pilla, knowing that
I had previous experience working in fruitful partnership with the
Church and the Vatican, approached me with the idea of organizing for
Cleveland an exhibition of works of art from the Vatican. I embraced the
idea immediately, realizing that such an occasion could provide the im-
petus for a truly outstanding exhibition that in normal circumstances
would probably never be possible. In Rome the role of chief advisor,
counsel, and friend at court was effectively filled by Monsignor Timothy
Broglio, assistant to the secretary of state of the Vatican. Father Broglio's
devotion to the task can only have been intensified by the fact that he was
born and raised in Cleveland Heights, Ohio. The exhibition would never
have come to pass without his diplomatic intervention.

The works in the exhibition derive from several administratively dis-
tinct parts of the Vatican. In the Vatican Library we are indebted to
the former prefect, Father Leonard Boyle, O.P., and especially to Dr.
Giovanni Morello, director of the Museo Sacro, from which the greatest
number of objects have been lent. In the Vatican Museums we thank Dr.
Francesco Buranelli, director; Dr. Edith Cicerchia, secretary; Dr. Arnold
Nesselroth, curator; and Dr. Alessandra Uncini, registrar. The extraordi-
nary loan of the *Cross of Justin II* from the Treasury of Saint Peter's was
made possible through the generosity and confidence of Cardinal Virgilio
Noè, archpriest of the Vatican Basilica; Monsignor Michele Basso, cham-
berlain of the Chapter of the Vatican Basilica; and Monsignor Piero
Marini, master of the Liturgical Celebrations of the Supreme Pontiff.
Cardinal Angelo Sodano, secretary of state, carries the final responsibility

for approving loans from the Vatican collections. We are grateful to him for his confidence in our ability to care for the precious and sacred works generously lent to the museum.

The Cleveland Museum of Art is fortunate to have in its collections several works resulting from papal commissions. We have included these pieces in the exhibition, although they are not illustrated in the catalogue, along with two additional related works geneously lent by the Walters Art Gallery in Baltimore and the Saint Louis Art Museum.

At the Diocese of Cleveland, Bishop Pilla was, of course, the guiding spirit for our work. Richard Krivanka and Sister Laura Bouhall, O.S.U., tracked the exhibition's organization and offered important suggestions along the way. At Associated Catholic Charities, August Napoli provided the impetus for developing the exhibition's primary financial support.

At the Cleveland Museum of Art, I had the good fortune to have had from the outset an able and enthusiastic collaborator in the person of the museum's chief curator, Dr. Diane De Grazia, a noted specialist in Italian Renaissance and baroque art and an experienced hand in the workings of the Vatican Museums. She is responsible for the lion's share of the objects and wrote the majority of the catalogue. Her travels to and conversations with Rome to negotiate and fine-tune the details were essential to the show's success. Assistant Curator of Medieval Art Stephen N. Fliegel responded immediately to our request that he prepare the catalogue entries on the illuminated manuscripts, and he exercised exemplary care and thoroughness in his efforts. The exhibition's logistics were coordinated by Chief Registrar Mary E. Suzor, with Victoria Foster and Beth Gresham among her able staff. Exhibition Coordinator Katie Solender choreographed numerous organizational details. The show's dramatic installation was the brainchild of Exhibition Designer Jeffrey Baxter, and its lighting was conceived and executed by Lighting Designer Christopher Tyler. The production of this catalogue depended on the publications team of Editor Barbara J. Bradley, Designer Thomas H. Barnard III, and Production Manager Charles Szabla. The considerable battery of educational and public programs associated with the show was the responsibility of Coordinator of Adult Programs Joellen DeOreo. Deputy Director Kate Sellers and Manager of Corporate Relations Jill Barry coordinated efforts at the museum to seek financial support for the exhibition.

An undertaking such as *Vatican Treasures* involves considerable expense. The primary support for the exhibition and related programs was provided by a generous grant from the F. J. O'Neill Charitable Corporation, through the good offices of the Associated Catholic Charities. We are deeply grateful to Nancy O'Neill for her support of this project and for her ongoing support of the museum's efforts. Additional major funding was afforded by a grant from The Illuminating Company, a FirstEnergy Company. A critical component in the success of the exhibition was the provision of insurance indemnification through the indemnity program of the Federal Council on the Arts and the Humanities.

To all the individuals, foundations, and organizations listed above I offer thanks for allowing us to make *Vatican Treasures* a reality for Cleveland and its visitors during the sesquicentennial year of the Diocese of Cleveland.

Robert P. Bergman, Director

THE EXHIBITION

Through their patronage and the gifts accorded them by emperors, kings, and other potentates, the almost 2,000-year succession of popes has inspired an extraordinary range of art made in the service of the sacred and the spiritual. Because they were designed for the apex of the Church's hierarchy, many of these works were commissioned from the most exalted artists and craftsmen of their time. The subsequent association of these works with the papacy has only added to their luster. In this highly focused exhibition we are privileged to present more than thirty of the most compelling sacred works in the papal collections.

The exhibition is conceived as a sequence of three sections encompassing the early medieval, Renaissance, and baroque eras. While not intended to represent the full scope of papal history, the works were selected with an eye toward providing range in time and type of object, and with an interest in representing several particularly vibrant moments in the history of the papacy's relationship with artistic production. The ensemble incorporates a number of themes and subthemes. While its contents range over about a millennium of history, from the Byzantine sixth century to the baroque splendor of the seventeenth, the majority of the works from all periods are connected with the cult of relics and the celebration of the liturgy. Taken together, this group bespeaks the constancy of the papacy as an institution over the centuries—indeed, to the present day. And in a number of ways, despite the great variety of material, form, and style, consistent threads in subject matter (an emphasis on Passion and Resurrection images) and modes of expression (an emphasis on narrative) tie the works together. The significant presence of images of the popes and/or inscriptions bearing their names provides telling testimony to the close bond between Peter's successors and the world of images.

The Byzantine and early medieval objects in the exhibition constitute, quite simply, the most important group of such works ever shown outside the Vatican. *The Cross of Justin II,* the centerpiece of the Treasury of Saint Peter's, has never before crossed the Atlantic. Its gilt and jeweled nature appropriately reflects its origins as an imperial gift offered by the emperor Justin II (reigned 565–78) to the pope. It is a perfect assimilation of sumptuousness to sacredness. As a reliquary cross it relates to the following series of objects from the Sancta Sanctorum Treasure, many of

which had a reliquary function. In experiencing such works, please keep in mind that their impact and meaning is both crafted by their maker and conveyed by the religious and mystical power of the relics they house. These are in many cases unique objects of tremendous aesthetic and art historical importance. Their unsurpassed quality, in combination with their spiritual power, accounts for their unusually compelling nature. Not since the discovery and exhibition of the treasure in 1903 has such an important selection of works from the Sancta Sanctorum—the private chapel of the popes in the Lateran Palace, their residence in Rome prior to the Renaissance—been permitted to leave the Vatican.

The core of the Renaissance section is also liturgical in nature. Here, two of the manuscripts and the vestments selected for the exhibition all relate to that most exalted of papal spaces, the private chapel of the papal household in the Vatican palace: the Sistine Chapel. The chapel was commissioned in the fifteenth century by Sixtus IV, who had its side walls decorated with scenes from the lives of Moses and Christ painted by Botticelli, Perugino, and other leading masters of the day. It was under Julius II that Michelangelo was commissioned to create the frescoed ceiling that has come to be regarded as one of the sublime works created by the human mind and hand. One of the manuscripts in the exhibition is a book of statutes that governed the conduct of the chapel by the papal household, while a second, the antiphonary, was actually used in the conduct of the Mass in the Sistine Chapel in the sixteenth century. *The Christmas Missal of Alexander VI* from 1492–94, one of the Vatican's greatest treasures of Renaissance manuscript illumination, served the pope at the high altar in Saint Peter's.

The suite of vestments presented to Clement VIII by the archduke of Tuscany in the 1590s is, in turn, surely the finest ensemble of liturgical vestments to have survived from the Renaissance. The group was in all probability presented specifically for use in the Sistine Chapel. It is remarkable to think of these luminous pieces, woven with gold and silver threads, being worn by the various members of the clergy in conducting the ceremony and as appurtenances of the altar. The scenes represented in their numerous pictorial fields, many the equivalent in scale and character of individual paintings, emphasize the later life and Passion of Christ. They complement the frescoes of Michelangelo on the ceiling, the fifteenth-century wall paintings, and the magnificent tapestries de-

signed by Raphael for the lower walls. When on special occasions all this pictorial splendor was arrayed in ensemble fashion it must have created one of the most remarkable kaleidoscopes of sacred imagery the world has ever seen.

Finally, in the baroque part of the exhibition are exhibited a number of works created in conjunction with Vatican commissions by the greatest of the papal architect/artists of the seventeenth century, Gian Lorenzo Bernini. The centerpiece of this section is one of the few works in the exhibition owned by the Vatican but not originally created for one of the popes. Caravaggio's monumental *Entombment,* one of the most famous paintings in the Vatican collections and among the most important early works by this revolutionary master of the baroque style, stands as a dramatic and appropriate climax for the exhibition. Painted for the Vittrici Chapel in the Chiesa Nuova (Santa Maria in Valicella), its direct and dramatic impact on the emotions of those who view it testifies to a new approach in the devotional arts invented in response to the theology of personal devotion and the theological politics of the post-Reformation period around 1600.

From the relic-based potency of the Byzantine and medieval works to the pictorial and narrative splendor of the Renaissance manuscripts and vestments to the appeal to the emotions of Caravaggio, we witness a striking adaptive range of modes that communicate essential aspects of the faith in the context of liturgical practice.

The emphasis in the exhibition on works commissioned by or presented as gifts to the popes and, in particular, the inclusion of a majority of works originally used in the successive private chapels of the popes at the Lateran and the Vatican has allowed for a show of remarkable works of art that, despite its temporal range, is quite focused in character. The character of the exhibition is also appropriate to the celebration of the sesquicentenary of the Diocese of Cleveland. The establishment of the diocese represents the formalization of the presence of the Church's hierarchy in Cleveland. The presentation of this selection of papal objects, many associated with the papacy's most sacred spaces, symbolizes in profound fashion the bond between the diocese and the Vatican. RPB

THE VATICAN COLLECTIONS are housed in a number of museums, the Musei Vaticani, established during different periods in the history of the Church. The personal collections of the popes form the nucleus of these museums. Over the years the diverse collections of the popes and their families, gifts, archaeological discoveries, confiscated art works, and purchases were scattered not only in the various buildings of the Vatican complex but in other papal residences as well. Only in the early sixteenth century did these collections begin to assume the shape of what today would be considered a museum complex.

Some of the earliest collections comprised the popes' private objects that were moved to the Vatican in the Renaissance. Chief among these were the works belonging to Julius II. The first objects to enter the Vatican collections under Julius II were the ancient Roman statues set up to adorn the gardens and form the "Antiquario" on the hillside of the Belvedere Palace. Not until the eighteenth century, however, were the classical antiquities to be housed in a proper museum, the Museo Pio-Clementino, begun in 1771 and completed in 1784. Julius's commissions for the Apostolic Palace—from Raphael of the Stanza della Segnatura (the papal library, 1509–11) and from Michelangelo of the Sistine Chapel ceiling (the papal chapel, 1508–12)—were destined to become the centerpieces of the entire modern Vatican museum complex.

One of the earliest of all the papal collections was that of the papal library, already justly famous in the fifteenth century. In addition to the many manuscripts (and, later, printed books) belonging to the popes and to the papal curia, the papal library included vases, medals, gems, natural history objects, and antiquities for decoration, as was normal for Renaissance libraries. In the middle of the sixteenth century the library was further enriched with collections of ancient coins and relics. In 1756 Benedict XIV instituted the Museo Sacro (Museo Cristiano) within the library, bringing together there all the nonmanuscript and nonbook materials of Christian subject. In 1852 Gregory XVI transferred all the objects discovered in the catacombs to the Museo Sacro, and in 1907 Pius X enriched the museum with the incomparable reliquaries and other objects from the Sancta Sanctorum Treasure in the Lateran. In 1767 the Museo Profano, including the coins and classical antiquities, came into being. The

VATICAN CITY

Leo IV's
Walls

Vatican
Museums
and Library

Saint Peter's
Basilica

Sistine
Chapel

Saint Peter's
Square

book and manuscript holdings of the Vatican Library are now among the richest in the world, and the library also houses an important collection of drawings and prints.

The Treasury of Saint Peter's is housed in the basilica itself and consists of liturgical objects and furnishings donated to the church by pilgrims from the time of Constantine (fourth century) to the present. Many of these are used for services in the great basilica on special occasions. The Great Schism (1378–1417), civil wars of the fifteenth century, the sack of Rome in 1527, and Napoleonic looting in the late eighteenth century—to name only a few moments of degradation—have all served to reduce the Church's treasure. The centerpiece of the treasury—the *Cross of Justin II*—has remained in place for almost 1,500 years.

Until 1790 the only museum for pictures was not housed in the Vatican complex but located in the Capitoline Palace, whose façade fronts on Michelangelo's magnificent Piazza del Campidoglio. In that year the Pinacoteca, a small picture gallery, was opened in the Vatican, and paintings from the various papal residences were transferred to it. Following the plundering by Napoleon's troops in 1798 the Pinacoteca was closed. When it reopened in 1830 it was hung with masterpieces owned by the Vatican and with plunder from elsewhere in Rome that had been returned by the French; it was at this time that Caravaggio's *Entombment* entered the Pinacoteca. Not until 1932 did the Pinacoteca—whose collections were once again enlarged with the transfer of works from other parts of the Vatican and beyond—find a permanent home in a building constructed for it within the confines of the Vatican.

Other museums grew up in the nineteenth and twentieth centuries. The Museo Chiaramonti, housing ancient sculpture, was founded by Pius VII in 1806–7; the Museo Gregoriano Etrusco, containing the Etruscan collections, and the Museo Gregoriano Egizio, for the Egyptian collections, were established by Gregory XVI in 1837 and 1839, respectively; the Museo Profano Lateranese and the Pinacoteca Lateranese (both in the Lateran Palace) opened in 1844; and the Museo Pio Cristiano was created by Pius IX at the Lateran in 1854 for the early Christian sarcophagi and the inscriptions. The Pontificio Museo Missionario-Etnological, featuring ethnographical collections brought back from missions around the world, was established at the Lateran in 1925. The Lateran museums were closed

in 1963 and later reopened in a new wing of the Vatican (1963–78) called the Museo Paolino in honor of Paul VI. A department of contemporary art was instituted by Pius XII in 1957 to house the gifts of modern art received by the popes. The Museo Storico, which opened in 1973, houses carriages, automobiles, and papal arms. The most recent museum, the Gallery of Modern Religious Art, opened in 1973.

The Musei Vaticani have been in a constant state of growth and development since their inception in the Renaissance. Improvements and changes continue at this museum of museums, which in its 500-year history has come to be one of the most extraordinary museum complexes in the world. DDG

1. THE CROSS OF JUSTIN II

565–78, CONSTANTINOPLE. GILT SILVER AND PRECIOUS STONES
40 X 32.4 (15¾ X 12¾)
TREASURY OF SAINT PETER'S

The Cross of Justin II, also known as the Crux Vaticana, is the most important object in the Treasury of Saint Peter's basilica and one of the most significant sacred luxury objects that survives from the early Byzantine period.

The cross is of the Latin type, with its lower vertical arm longer than the three upper arms. Each of the arms flairs toward its outer extremity. On the front at the center is a relic of the True Cross in a round reliquary compartment (a modern replacement created in the late nineteenth century during the papacy of Pius IX). The perimeter of the cross is decorated with alternating large and small cabochon gems. Six of the large stones are modern replacements, as are all of the small circular stones that replace the original pearls. Four additional stones (probably modern replacements) are suspended on loops from the horizontal arms. The elaborate use of inset gems categorizes this cross as a *crux gemmata* (jeweled cross), a type well known from early Byzantine texts and representations. The cross's lower portion was designed to be inserted into a base, probably to allow display on an altar.

A flat metal sheet on the front face of each arm carries an incised Latin inscription: LIGNO QVO CHRISTVS HVMANVM SVBDIDIT HOSTEM / DAT ROMAE IVSTINVS OPEM SOCIA DECOREM (The wood [of the cross] where the human Christ was placed by his enemy/Justin and his wife gave Rome this beautiful work). Paleographical analysis supports a dating for the inscription in the tenth or eleventh century, when the cross was apparently restored. It probably repeats an older inscription recording the name of the donor, Justin, undoubtedly the emperor Justin II, who reigned at Constantinople from 565 to 578. The cross was most likely a gift from the emperor to Pope John III.

The reverse side is quite different from the front. Here the decoration is repoussé and features a large central medallion depicting the Agnus Dei carrying a cross-staff and, on the arms, four smaller medallions. Those on the horizontal arms contain busts of the emperor (left) and his wife, Sophia (right), while those on the vertical arms display two busts of the nimbed Christ, one carrying a book (top), the other a cross-staff (bottom). The imperial figures, shown with their arms raised in prayer, wear abbreviated imperial costumes and elaborate headgear. Four long *pendulia* hang from the empress's crown. A foliate candelabra ornament connects the medallions vertically; a vine scroll unifies the elements of the horizontal arms.

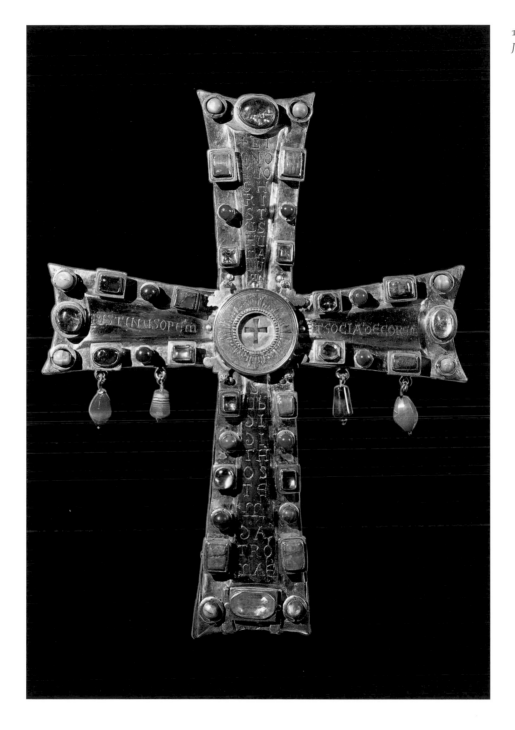

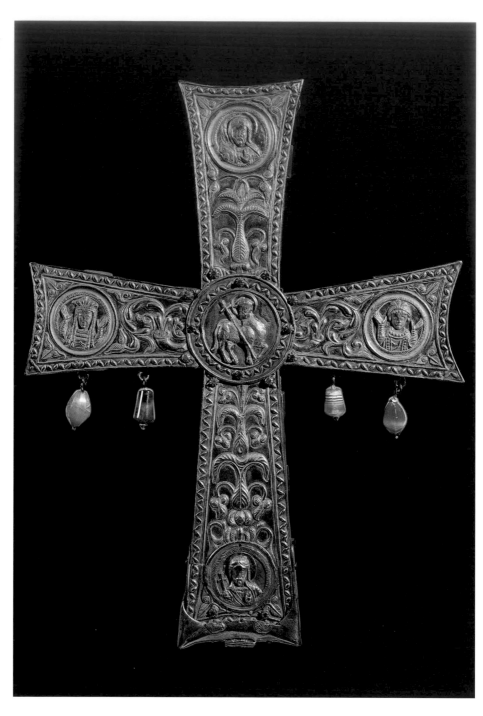

This imperial-papal gift derives its meaning from the sacredness of the relic of the True Cross and the sumptuousness of the vessel designed for its display. While the hierarchy of elements on the reverse grants primacy to the Lamb of God, whose sacrificial nature surely alludes to the sacrifice of Christ on the cross, the prominence of the imperial donor portraits introduces an intriguing and conspicuous interplay of the sacred and the imperial in which the latter occupies a remarkably elevated position.

The hard, stylized quality of the figures and ornament is characteristic of the "abstracting" tendencies that came to the fore in Byzantine art of the sixth century, particularly during the long reign of Justinian. Indeed, in the realm of imperial luxury arts, the *Cross of Justin II* is the primary preserved example of this style, which has parallels in notable examples of liturgical silver, such as the *Homs Vase* in the Louvre, and works in various other media, such as the mid–sixth-century stuccos in the church of San Vitale in Ravenna. RPB

REFERENCES

Guglielmo Cavallo et al., *I Bizantini in Italia* (Milan, 1982), 409; Christa Belting-Ihm, "Das Justinuskreuz in der Schatzkammer," *Jahrbuch des Römische-Germanischen Zentralmuseum, Mainz,* 12 (1965), 142–46; Victor H. Elbern, "Zum Justinuskreuz im Schatz von Sankt Peter zu Rom," *Jahrbuch der Berliner Museen* 6 (1964), 24–38; Villa Hugel, *Frühchristliche Kunst aus Rom* (Essen, 1962), 221, no. 463; Marc Rosenberg, "Ein goldenes Pektoralkreuz," *Pantheon* 1 (1928), 151–55.

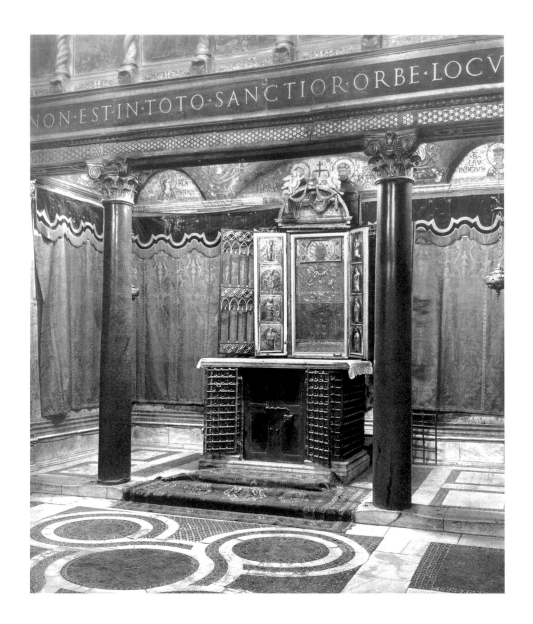

The Sancta
Sanctorum Treasure
in the Chapel of
Saint Lawrence at
the Lateran Palace

THE SANCTA SANCTORUM TREASURE

THE SIX WORKS THAT FOLLOW, in addition to the *Cross of Justin II*, constitute the most important group of early medieval objects owned by the popes. All six were part of a great cache of sacred relics and objects, known as the Sancta Sanctorum Treasure since the pontificate of Leo III in the ninth century and added to by subsequent medieval popes. Leo had the core of this treasure placed in a cypress chest and inserted into the altar of the Chapel of Saint Lawrence in the Lateran Palace, the papal home in Rome until the court was transferred to the Vatican after the popes' return from exile in Avignon in 1377. The Chapel of Saint Lawrence was the pope's private chapel and thus the predecessor of the Sistine Chapel, the private chapel of the papal household at the Vatican. The Lateran chapel housed the famous relics of the heads of Saints Peter and Paul and, on the altar, Rome's most important icon: a miraculous image of Christ *acheiropoietos* (not made by human hands). The presence of such transcendent relics and images motivated the designation of the chapel as the Sancta Sanctorum (the Holy of Holies).

Remarkably, over many centuries the Sancta Sanctorum Treasure escaped destruction. An inventory of its contents was made in the twelfth century by John the Deacon, and a small number of Renaissance clerics viewed the treasure. Otherwise, it remained virtually untouched and unseen until 1903, when Leo XIII opened the shrine. At the order of Pius X the treasure was brought to the Vatican Library for safekeeping and study in 1907, with the relics to remain in the shrine under the altar of the Chapel of Saint Lawrence at the Lateran. The reliquaries and other objects were placed on permanent deposit in the Museo Sacro of the Vatican Library, where they have been on public view since 1934. RPB

REFERENCES

Vatican City, *Sancta Sanctorum* (Milan, 1995); Giovanni Morello, "Il tesoro del Santa Sanctorum," in Carlo Pietrangeli et al., *Il palazzo apostolico lateranese* (Florence, 1991); Adriano Prandi in Leonardo Von Matt et al., *Art Treasures of the Vatican Library,* *Museo Profano/Museo Sacro* (New York, 1970), 73–75; Hartmann Grisar, S.J., *Die Römische Kapelle Sancta Sanctorum und ihr Schatz* (Freibourg, 1908); Philippe Lauer, "Le Trésor du Sancta Sanctorum," *Monuments et Memoires* 15 (1906).

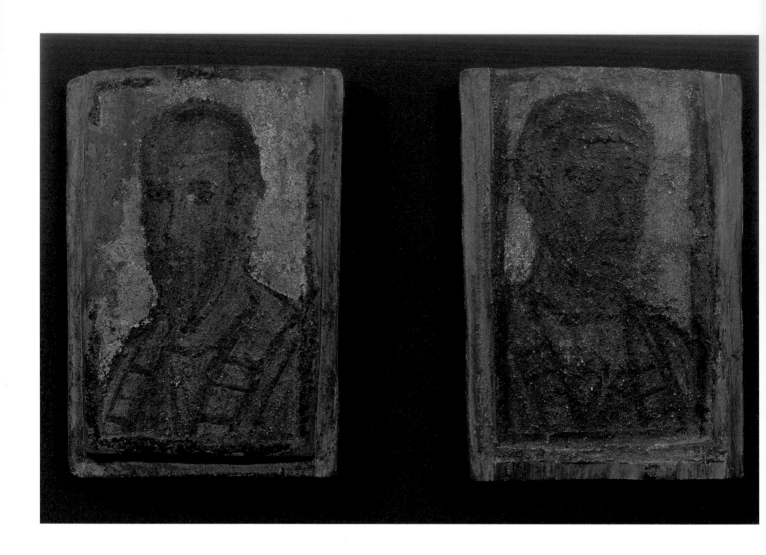

*2. Diptych with
Portraits of Peter
and Paul*

2. DIPTYCH WITH PORTRAITS OF PETER AND PAUL

6TH–7TH CENTURY, ROME (?). ENCAUSTIC ON WOOD
TWO PANELS, EACH 8.6 X 5.7 (3⅜ X 2¼)
BIBLIOTECA APOSTOLICA VATICANA, MUSEO SACRO, 1911

These small wooden panels apparently fit together to form a very thin container. The panel with Saint Paul is configured so that it would slide into the panel with Saint Peter. The portraits would be visible only when the panels were separated. The exterior of the panels would have been treated with wax or some other material and probably carried an inscription. The purpose of this unique object remains unknown.

Although some have been tempted to date this object to a very early period (that is, the third or fourth century), there is no basis for such an attribution. Most probably the two portraits were painted in the sixth or seventh century, when the tradition of icon painting had become more developed. While stylistic comparisons are difficult to draw with these works, they seem to share little in common with early Byzantine objects and are most likely of local, Roman origin. RPB

REFERENCES
Giovanni Morello in Angela Donati, ed. *Dalla terra alle genti. La diffusione del cristianesimo nei primi secoli*, exh. cat., Palazzi dell'Arengo e del Podestà (Milan, 1996), 209, cat. no. 54; Prandi in Von Matt, *Art Treasures of the Vatican Library*, 171; Grisar, *Römische Kapelle Sancta Sanctorum*, 118–19; Lauer, "Trésor du Sancta Sanctorum," 83–84.

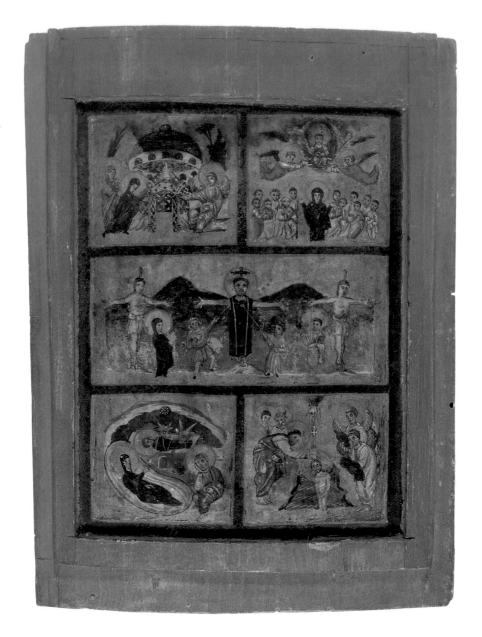

3. Painted scenes showing, from the bottom left, the Nativity, the Baptism of Christ, the Crucifixion, the Marys at the Tomb, and the Ascension. *Reliquary Box with Stones from the Holy Sites of Palestine*

3. RELIQUARY BOX WITH STONES
FROM THE HOLY SITES OF PALESTINE

6TH–7TH CENTURY, PALESTINE
WOOD, TEMPERA, AND GOLD LEAF. 24.1 X 18.4 X 4.1 (9½ X 7¼ X 1⅝)
BIBLIOTECA APOSTOLICA VATICANA, MUSEO SACRO, 1883A–B

This painted box, though modest in scale, is one of the most evocative and compelling objects to have survived from early Palestine, indeed from the whole of the early Christian world.

Pilgrims to meaningful religious sites have always wanted to take away "souvenirs" of their experience. In the early Christian period such remembrances generally took the form of flat terracotta tokens or ampullae (small lead or terracotta vessels) that held a drop of oil taken from a lamp at the holy site. Some of these relatively mass-produced objects were identified merely by inscription; others were adorned with a simple image relating to the site. If the lead ampullae preserved in the treasury of the cathedral at Monza in Italy are the best-known group of such figurated objects to come from the holy sites of Palestine, this painted reliquary box is by far the single most important.

The stones inside the box are like a sacred topography of the Holy Land. They come from several of the most significant locales associated with Christ's life. Among the Greek inscriptions legible on the stones set into the clay floor are "From the place of the Resurrection," "From the Mount of Olives," "From Bethlehem," and "From Zion." The pictures on the inside of the lid represent events associated with five of these sites and form the most important cycle of such holy site pictures to have come down to the modern world.

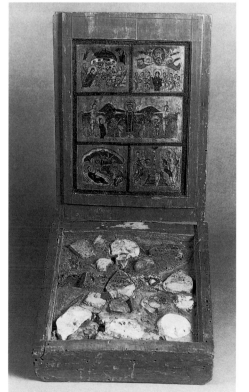

3a. The reliquary box open, showing the scenes from the life of Christ and stones from the holy sites of Palestine

The sequence begins with the Nativity at the lower left, the site of Christ's birth in Bethlehem. The Virgin reclines on her bed, at whose foot sits a pensive Joseph. Wrapped in swaddling clothes, the little Christ child lies in the cave adored by the ox and ass of apocryphal literature. At the center top is the star described in the Gospels as appearing above the locale of the miraculous event. Although later Western traditions describe a stable, in the early Greek-speaking parts of the Mediterranean world the site was thought to be a cave. Indeed, to this day, it is to such a setting that one makes pilgrimage beneath the Church of the Nativity in Bethlehem. The little niche that appears beneath the cave's opening in the reliquary may even refer to an actual niche where a lamp was hung at the site in Bethlehem.

At the lower right is Christ's Baptism. In the early fourth century Constantine had set a large cross on the banks of the Jordan that became a pilgrimage site. John the Baptist, accompanied by two disciples, is shown at the left standing on the banks of the Jordan. He reaches over to anoint the head of the small nude figure of Christ, who stands in the middle of the river. On axis above Christ's head appear the dove of the Holy Spirit and the hand of God. Two angels bearing garments appear on the river's far bank.

The double-sized central field is reserved for the Crucifixion, the site-picture for Golgotha, where the event took place. Against a background of stylized hills, Christ is shown on the cross at the center, flanked by the crucified good and bad thieves. The Virgin and John the Evangelist witness the event while Longinus and Stephaton torment Christ with sword and sponge.

Early Christian artists did not represent the Resurrection itself. Instead they indicated the event with images of the moment when the Marys (either two or three) arrived at the tomb to find it empty. The angel seated at the tomb heralds the fact that Christ has arisen. Precisely this scene, the Marys at the Tomb, is depicted at the upper left. It is the site-picture for Christ's Tomb, on the side of the hill of Golgotha, arguably the central place of pilgrimage in the Holy Land. While the archaeology of this site is complex, the tomb itself (the altar-like structure surrounded by a type of column-and-grille arrangement and the large dome that hovers above it) probably reflects the architectural situation at the Anastasis Rotunda, the sixth- or seventh-century domed structure that housed the tomb. Today's Holy Sepulcher, as it is now usually called, is a much later structure dating from the Crusader period and reworked many times.

The Ascension is the last picture in the sequence. Christ appears seated in a mandorla borne aloft by four angels. The Virgin, her arms raised in prayer, stands below in the center accompanied by the Apostles. The Ascension is the site-picture for the Mount of Olives, where the event is believed to have occurred and where today stands a small Crusader-period structure known as the Church of the Ascension.

Although reduced and abbreviated, the figure style apparent in the paintings ultimately derives from the classical tradition. The extreme stylizations of the later Middle Ages are not yet in evidence; instead, the figures and their actions reflect simplified versions of the imitative types of antiquity. Among the few closely related works most pertinent are the illuminations in the Syriac Rabula Gospels dated 586 (Laurentian Library, ms. Plut. I 56, Florence), which display correspondences not only in figure style but in iconography as well. For example, Christ on the cross wears the long, sleeveless garment known as the colobium in both the Rabula and wooden reliquary Crucifixion. Although this feature occurs in later Byzantine examples as well, there is little doubt that its origin is Palestinian. Various other details of iconography have parallels in the Monza ampullae, certainly products of sixth- to seventh-century Palestine. RPB

REFERENCES

Morello in Donati, *Dalla terra alle genti*, 325–26, cat. no. 250; Anton Legner, ed., *Ornamenta Ecclesiae: Kunst und Künstler der Romanik* (Cologne, 1985), 3:80–81, no. H8; Gary Vikan, *Byzantine Pilgrimage Art* (Washington, D.C., 1982), 18–20; Kurt Weitzmann, "*Loca Sancta* and the Representational Arts of Palestine," *Dumbarton Oaks Papers* 28 (1974), 31–55; Prandi in Von Matt, *Art Treasures of the Vatican Library*, 171; C. R. Morey, "The Painted Panel from the Sancta Sanctorum," in *Festschrift Paul Clemen* (Bonn-Dusseldorf, 1926), 151ff; Grisar, *Römische Kapelle Sancta Sanctorum*, 113; Lauer, "Trésor du Sancta Sanctorum," 97–99.

*4. Reliquary of
the True Cross
(The Cross of Pope
Paschal I)*

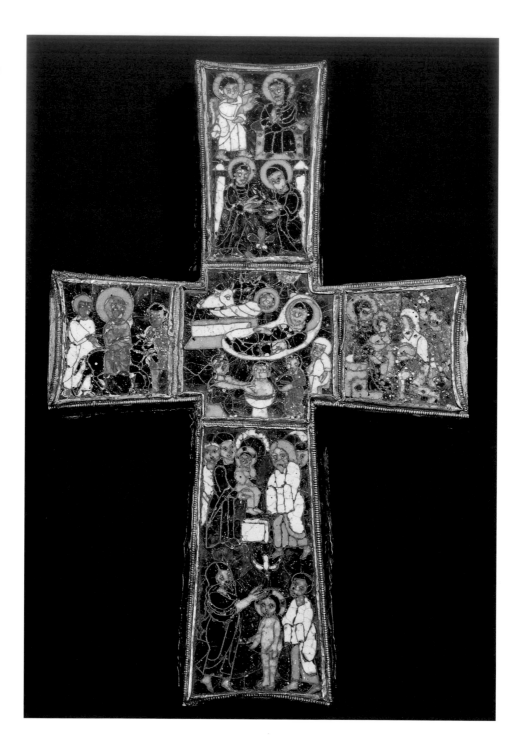

4. RELIQUARY OF THE TRUE CROSS
(THE CROSS OF POPE PASCHAL I)

817–24, PALESTINE OR ROME (?). GOLD AND CLOISONNÉ ENAMEL
27 X 18 X 3.5 (10⅝ X 7 X 1⅜)
BIBLIOTECA APOSTOLICA VATICANA, MUSEO SACRO, 1881

The Cross of Pope Paschal I is the most important early medieval enamel to have come down to the modern world. Contemporary with the revival of art making at the Carolingian court of Charlemagne and closely allied to the handful of other preserved early works in this delicate medium, the cross stands as the starting point of the brilliant history of enamel in both Byzantine and European medieval traditions.

Seven episodes from the early life of Christ are depicted on the preserved rear surface (presumably the front would have contained a representation of Christ on the cross): the Annunciation and Visitation (top);

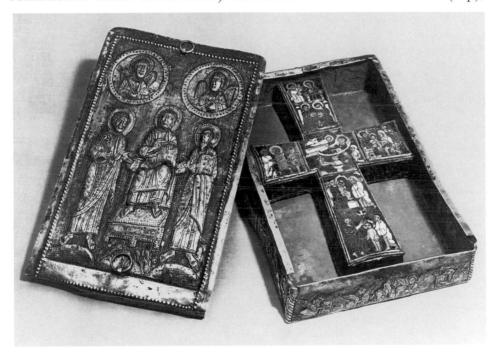

4a. *Reliquary of the True Cross* in its partially gilt silver casket

Journey to Bethlehem (left); Nativity (center); Adoration of the Magi (right); Presentation in the Temple and Baptism (bottom). The scenes, though represented in a simplified iconography and using a limited number of figures, powerfully express the essence of the narrative. The sequence is clearly conceived as a unified cycle intended to evoke crucial moments in the story of Christ's infancy.

The bold simplicity of the cross's style reflects the generally reductive tendencies of early medieval art, but the form is also materially affected by the technical aspects of the cloisonné medium. The compartments formed by soldering the dividing wires onto the gold surface reinforce the preference for creating forms as a series of juxtaposed rather than integrated shapes.

Inscribed in handsome capital letters around the perimeter is a dedicatory inscription. Although the inscription has been damaged and rearranged in a manner that destroys the sense of the Latin, it has been reconstructed to read: ACCIPE QVAESO A DOMINA MEA REGINA MVNDI HOC VEXILLVM CRVCIS QVOD TIBI PASCHALIS EPISCOPVS OPTVLIT (I beseech you, my sovereign, queen of the world, to accept this sign of the cross that is offered to you by Bishop Paschal). There is no doubt that the Paschal mentioned is Paschal I, arguably the most important patron of the arts among the early medieval popes. Because the inscription extols the dedication's recipient as "regina mundi," the cross may have been intended as a gift to a church or chapel dedicated to the Virgin.

Like the *Cross of Justin II*, the *Cross of Pope Paschal I* is a True Cross reliquary, designed originally to hold splinters of the True Cross, many of which were disseminated around the Christian world in the centuries following its discovery in the Holy Land by Queen Helena, Constantine's mother, in the early fourth century. Pieces of the True Cross were among the most revered of all the early Church's sacred relics.

Where the cross was made remains a matter of dispute. Some scholars believe it was made for the pope in Rome while others, on the basis of comparisons with objects produced in the Holy Land, point to Palestine as the probable place of origin. Since we know that during this period artists were migrating from parts of the Byzantine Empire to the West in the wake of the iconoclastic controversy (721–847), Palestinian artists may have produced the work in Rome. The Latin inscription supports a Roman attribution. RPB

REFERENCES

Gunther Haseloff, *Email im frühen Mittelalter* (Marburg, 1990), 77; Robert P. Bergman et al., *Splendor of the Popes*, exh. cat., Walters Art Gallery (Baltimore, 1989), 6–7, cat. no. 1; Legner, *Ornamenta Ecclesiae*, 3:82–84, cat. no. H9; Cavallo, *I Bizantini in Italia*, 335–36, 407; Marie-Madeleine Gauthier, *Émaux du moyen age* (Fribourg, 1972), 45–46; Prandi in Von Matt, *Art Treasures of the Vatican Library*, 173; Klaus Wessel, *Byzantine Enamels* (Greenwich, Conn., 1967), 46–50 (reprint, Shannon, Ireland, 1969); A. Frolow, *La relique de la Vraie Croix*, Archives de l'Orient Chrétien 7 (1961), 215–16, no. 88; Friedrich Stohlman, *Gli smalti del Museo Sacro Vaticano* (Vatican City, 1939), 16–22, 47–48; M. Rosenberg, *Geschichte der Goldschmiedekunst auf technischer Grundlage* (Frankfurt, 1921), 3:41–62; Grisar, *Römische Kapelle Sancta Sanctorum*, 62–69; Lauer, "Trésor du Sancta Sanctorum," 40–49.

5. CASKET FOR THE RELIQUARY CROSS OF POPE PASCHAL I

817–24, ROME. PARTIALLY GILT SILVER

30 X 19.7 X 6.2 (11⅞ X 7¾ X 2½)

BIBLIOTECA APOSTOLICA VATICANA, MUSEO SACRO, 1888

Like the Paschal Cross, the silver and partial gilt rectangular container that held it and the related box (cat. no. 6) are unusual among medieval precious objects. Made of two thick (1.5 mm) sheets of silver, this casket was cut and bent to form its shape, the decoration done using the repoussé technique in which the forms are hammered out from the rear. From textual descriptions and inventories it is evident that such rich metalwork was widespread in Rome and in the Byzantine East in the early medieval period. Most has been lost, however, either destroyed or melted down because of the inherent value of the precious metal.

On the cover Christ is depicted seated on a backless cushioned throne, his feet resting on a footstool beneath which flow the four rivers of paradise. Saints Peter (carrying the keys) and Paul (carrying a book), the two pre-eminent "princes" of the Church, stand on hillocks at either side of the throne. Already the convention of depicting Peter with cropped hair and short beard and Paul with bald pate and long beard is in evidence. Two medallions containing busts of archangels carrying scepters complete the composition.

On the short side of the casket below the feet of the figures on the cover appears the central image of the Agnus Dei flanked by the four winged Evangelist symbols: ox (Luke), lion (Mark), man (Matthew), and eagle (John). This vignette should be read as one composition with the figures on the cover. Together they mimic the two-part compositions common in monumental apse mosaics and frescoes in Rome from the early Christian period. The other three sides of the vessel contain six narrative scenes from the Infancy cycle: the Annunciation, Visitation, Nativity, Annunciation to the Shepherds and Magi, Adoration of the Magi, and Presentation in the Temple. The selection of scenes is clearly different from that of the cross itself, but the emphasis on Infancy scenes in which the Virgin plays a key role relates to the cross's cycle and to the inscription's implication that Paschal offered this donation to a church or chapel dedicated to the Virgin.

The style of the figures and the details of their draperies have parallels in a number of Roman monuments, including several of the mosaics in Roman churches executed during the time of Paschal I. The precise origin of this flattened figure style and the method of rendering drapery with short, often parallel lines, while evident in early medieval Rome, may in fact be Palestinian. Several early Greek manuscripts exhibit a closely related style. Their place of origin has been disputed as being either southern Italy or Palestine. RPB

5. Christ on his throne with Saints Peter and Paul. *Casket for the Reliquary Cross of Pope Paschal I*

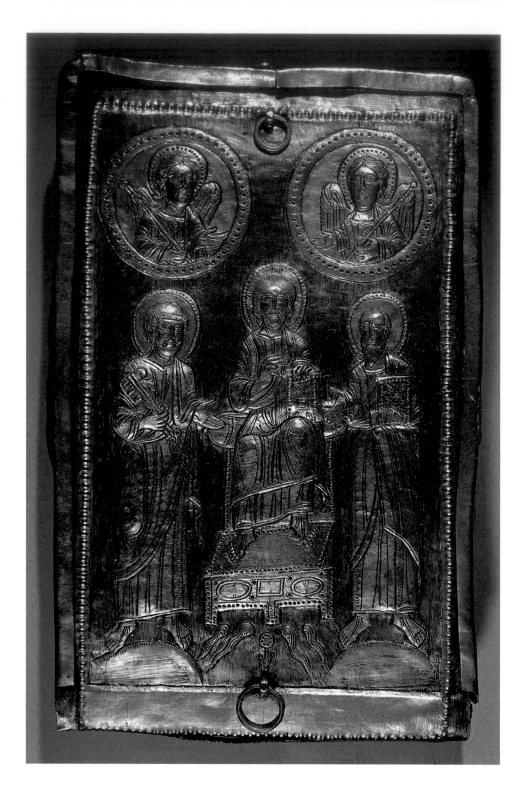

5a. The Agnus Dei flanked by the four winged Evangelist symbols. *Casket for the Reliquary Cross of Pope Paschal I*

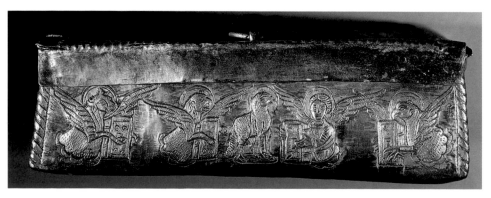

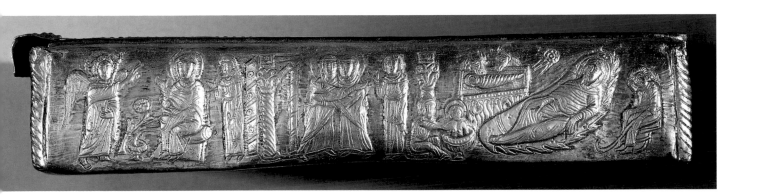

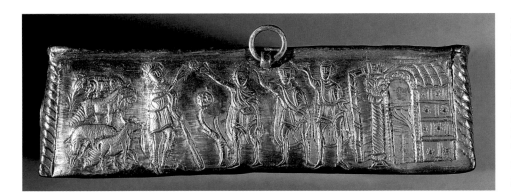

5b. The Annunciation, Visitation, and Nativity (top), the Annunciation to the Shepherds and Magi (center), and Adoration of the Magi and Presentation in the Temple (bottom). *Casket for the Reliquary Cross of Pope Paschal I*

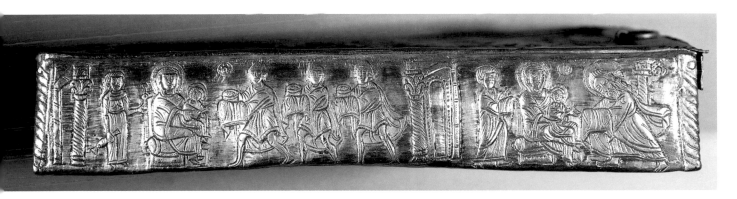

REFERENCES

The Vatican Collections: The Papacy and Art, exh. cat., Metropolitan Museum of Art (New York, 1983), 101–2, cat. no. 38; Victor Elbern, "Rom und die karolingische Goldschmiedkunst," in *Roma e l'età carolingia* (Rome, 1976), 345–55; Prandi in Von Matt, *Art Treasures of the Vatican Library*, 173; C. Cecchelli, "Il tesoro del Laterano," *Dedalo* 7 (1926–27), 138–66; Grisar, *Römische Kapelle Sancta Sanctorum*, 80- 83; Lauer, "Trésor du Sancta Sanctorum," 60–66.

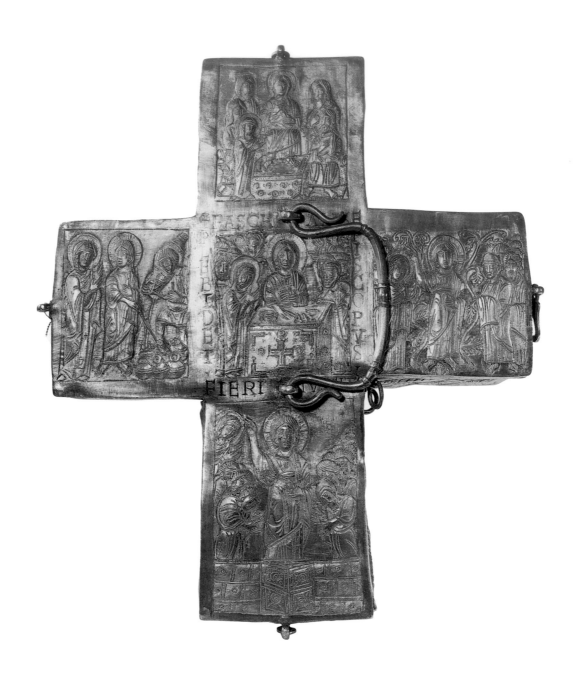

*6. Casket for a
Cross-Shaped
Reliquary*

6. CASKET FOR A CROSS-SHAPED RELIQUARY

817–24, ROME. PARTIALLY GILT SILVER, WITH NIELLO
29.5 X 25 X 9.8–10 (11⅝ X 9⅞ X 3⅞–4)
BIBLIOTECA APOSTOLICA VATICANA, MUSEO SACRO, 985

This container originally housed a second cross-reliquary. Smaller than the *Cross of Pope Paschal I*, it was encrusted with jewels. This cross was recorded in 1903 when the treasure was removed from its centuries-old place of repose in the Lateran but was subsequently lost. It is known only through photographs taken at the time of its discovery at the Lateran.

The casket was made at the order of Paschal I, as is attested by the inscription in niello surrounding the central scene on its cover: PASCHALIS EPISCOPVS PLEBI DEI FIERI IVSSIT (Bishop Paschal, servant of God, had this made).

The repoussé scenes that decorate the top and sides of the box form a detailed pictorial sequence, some elements of which are extremely rare. The lid includes five scenes. At its center is the Communion of the Apostles, in which Christ is depicted as if officiating at mass. This scene is a ceremonial or liturgical expression of the institution of the Eucharist, more often represented by the narrative episode of the Last Supper. The other scenes represented on the lid are the miracle at Cana (left), Christ among the doctors (top), Christ in the garden of Gethsemane (?) (right), and Christ preaching to the Apostles (bottom).

The twelve fields on the casket's sides show Christ in various post-Resurrection appearances, some of which defy precise identification. These episodes, drawn from the Gospels, present a synoptic narrative of these post-Resurrection events and may tentatively be identified as follows: Christ appears to the two Marys (Matthew 28:9); the Marys at the Tomb (Matthew 28:1); the two Marys announce the Resurrection to the Apostles (Matthew 28:10); Christ meets the two disciples at Emmaus

6a. The now-lost cross found in the *Casket for a Cross-Shaped Reliquary*

41

6b. *Casket for a Cross-Shaped Reliquary*

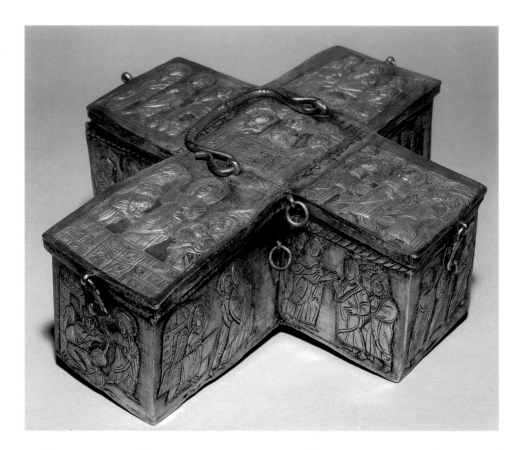

(Luke 24:13–15); the supper at Emmaus (Luke 24:30); Peter and a second disciple at the Tomb (John 20:3–9); the two disciples announce the Resurrection to the Apostles (Luke 24:3); an Apostle touches Christ (Luke 24:39); Christ appears to the Apostles behind closed doors (John 20:19); Doubting Thomas (John 20:26–29); Christ blesses the Apostles at Bethany (Luke 24:50); and Christ charges Peter to feed his sheep (John 21:17–18).

The lively narrative quality of the scenes and their density in relation to the Gospel text suggest that they may have been inspired by manuscript illuminations. The style is closely allied to that of the related reliquary (cat. no. 5) and is paralleled in other works, such as the mosaics in the Roman church of Santa Prassede, that date to the time of Paschal I. The stocky proportions of the figures and, in particular, the use of parallel incised lines to indicate the main folds of drapery can be found in these mosaics and other works from Paschal's period. Whether the style originated in Rome or was, in fact, derived from foreign, particularly Eastern, sources is another matter. The famous ninth-century illuminated manuscript of John of Damascus's *Sacra Parallela*, preserved in the Bibliothèque Nationale in Paris (ms. gr. 923), displays significant stylistic affinities, particularly in the drapery style of its golden-clad figures. If

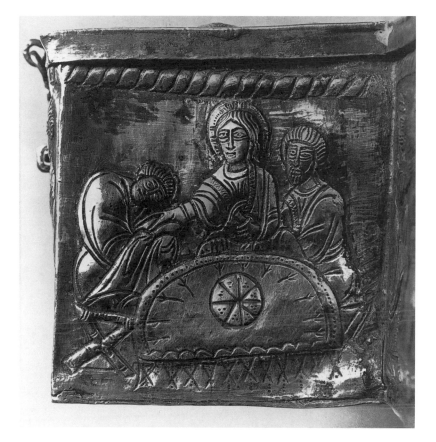

6c. The supper at Emmaus. One of the ends of the *Casket for a Cross-Shaped Reliquary*

Kurt Weitzmann is correct that this manuscript originated in the Holy Land, then the Paschal style may well have been significantly conditioned by the importation of Palestinian art and/or artists. Conversely, to André Grabar the Paris manuscript and its relatives are the products of a Greek scriptorium operating in southern Italy. Should his theory prove correct, the style's origins would appear to be much closer to home. RPB

REFERENCES

Legner, *Ornamenta Ecclesiae*, 3:85–86, cat. no. H10; *Vatican Collections*, 100–01, cat. no. 37; Elbern, "Rom und die karolingische Goldschmiedkunst"; Prandi in Von Matt, *Art Treasures of the Vatican Library*, 171–72; Cecchelli, "Il tesoro"; Grisar, *Römische Kapelle Sancta Sanctorum*, 97–100; Lauer, "Trésor du Sancta Sanctorum," 66–71. For a discussion of the Palestinian or Roman attribution of the related manuscripts, see André Grabar, *Les manuscrits grecs enlumines de provenance italienne, IX^e–XI^e siecles* (Paris, 1972), and Kurt Weitzmann, *The Miniatures of the Sacra Parallela, Parisinus Graecus 923* (Princeton, 1979).

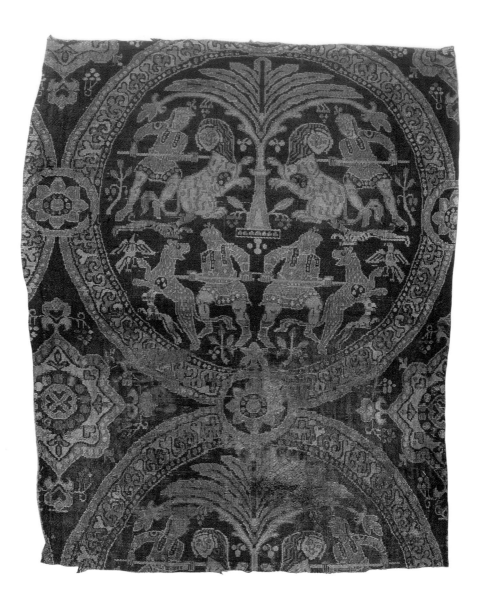

7. HUNTING TEXTILE

5TH–8TH CENTURY, EASTERN MEDITERRANEAN (SYRIA? EGYPT?)
SILK, COMPOUND TWILL. 42.4 X 34.7 (16¾ X 13⅝)
BIBLIOTECA APOSTOLICA VATICANA, MUSEO SACRO, 1250

Textiles with hunting scenes were popular during late antiquity, and a number of variations of the theme may be found in works beginning in the fifth century. The Vatican fragment is obviously part of a much larger whole—originally a garment or hanging—that featured a repeat pattern of medallions with hunting scenes interspersed with quadrilobed diamonds arrayed against a red background. The one preserved medallion on the Vatican fragment actually depicts two types of hunt. Above, two figures clad in short tunics and accompanied by dogs use long spears to pierce the flesh of two rearing lions. These vignettes, and the two below depicting similar figures and dogs engaged in a leopard hunt, symmetrically flank in almost heraldic fashion a central date palm tree. The background is further enlivened with compositional filler elements of birds and plants.

The overall compositional type featuring elements arrayed in repetitive roundels abounds in textiles and floor mosaics of the late antique period between the fifth and eighth centuries and has been dubbed the "medallion style" by textile scholar James Trilling. Whether the present example dates as early as the fifth century or as late as the eighth remains in dispute. Perhaps supporting the later date is the diadem worn by the (presumably royal) hunter, whose central cross element not only indicates the Christian character of the hunter but is most closely paralleled in the emperor portraits of Byzantine coins dating in the seventh and eighth centuries.

The *Hunting Textile*, whatever its original use, was discovered in 1903 wrapped around a pair of sandals, presumably Jesus's sandals—an important relic—inside the rectangular reliquary box (cat. no. 5) that also contained the *Cross of Pope Paschal I*. Textiles of such quality were highly prized, and very expensive, in the early Middle Ages. That many were used to wrap relics testifies to the esteem in which they were held; otherwise, they would not have been allowed to come into contact with such sacred objects. RPB

REFERENCES

James Trilling, *The Medallion Style: A Study in the Origins of Byzantine Taste* (New York, 1985), 56; Géza de Francovich, "La brocca d'oro del tesoro della chiesa di Saint-Maurice d'Agaune nel Vallese e I tessuti di Bisanzio e della Siria nel periodo iconoclastico," in *Arte in Europa: Scritti di storia dell'arte in onore di Edoardo Arslan* (Milan, 1966; reprinted in *Persia, Siria, Bisanzio e il Medioevo artistico europeo* [Naples, 1984], 174, no. 211); Cavallo, *I Bizantini in Italia*, 424; Prandi in Von Matt, *Art Treasures of the Vatican Library*, 174–75; Wolfgang F. Volbach, *I tessuti del Museo Sacro Vaticano* (Vatican City, 1942), 44–45, no. T118; Otto von Falke, *Kunstgeschichte der Seidenweberei* (Berlin, 1913), 1:12–13; Grisar, *Römische Kapelle Sancta Sanctorum*, 127–28; Lauer, "Trésor du Sancta Sanctorum," 118.

8. "SAMSON" TEXTILE

6TH–8TH CENTURY, EASTERN MEDITERRANEAN (SYRIA? EGYPT?)
SILK, COMPOUND TWILL. 19.7 X 16.4 (7¾ X 6½)
BIBLIOTECA APOSTOLICA VATICANA, MUSEO SACRO, 1247

Against a red background, a male figure wearing a short tunic is shown wrestling with a rearing lion. The man struggles with the beast from behind, holding its head with both hands and digging one knee into its back. An ovoid floral border frames the scene at top and bottom.

The scene portrayed may be interpreted in a number of ways. Its iconography fits the traditional classical labor of Hercules wrestling with the Nemean lion. Among Old Testament subjects, both Samson Wrestling with the Lion (the identification favored by most scholars) and David Wrestling with the Lion provide the most logical explanations. A number of scholars refer to the imagery simply as the "lion tamer."

The fragment relates to a group of similar textiles in various museums and church treasuries, the most notable of which are today preserved in the Victoria and Albert Museum in London; Dumbarton Oaks in Washington, D.C.; and the church treasury of Ottobeuren, Germany. The Ottobeuren fragment is believed to have arrived in that city wrapped around the relics of Saint Alexander, translated from Rome in AD 774, which may support a date for the whole group of fragments in the eighth century. Syria is most often mentioned as the place of manufacture for the group (and for the *Hunting Textile,* cat. no. 7, as well), but origins in Egypt and even Constantinople have also been proposed.

When discovered in 1903 the Vatican fragment formed part of a little bag containing several relics. In the restoration of the Sancta Sanctorum Treasure, the *"Samson" Textile* was blocked and mounted in its present form. RPB

REFERENCES
Cavallo, *I Bizantini in Italia,* 424–25; de Francovich, "La brocca d'oro," 184 (reprint); Prandi in Von Matt, *Art Treasures of the Vatican Library,* 175; Volbach, *I tessuti del Museo Sacro Vaticano,* 38–39, no. T103; von Falke, *Kunstgeschichte der Seidenweberei,* 1:9; Grisar, *Römische Kapelle Sancta Sanctorum,* 133; Lauer, "Trésor du Sancta Sanctorum," 119.

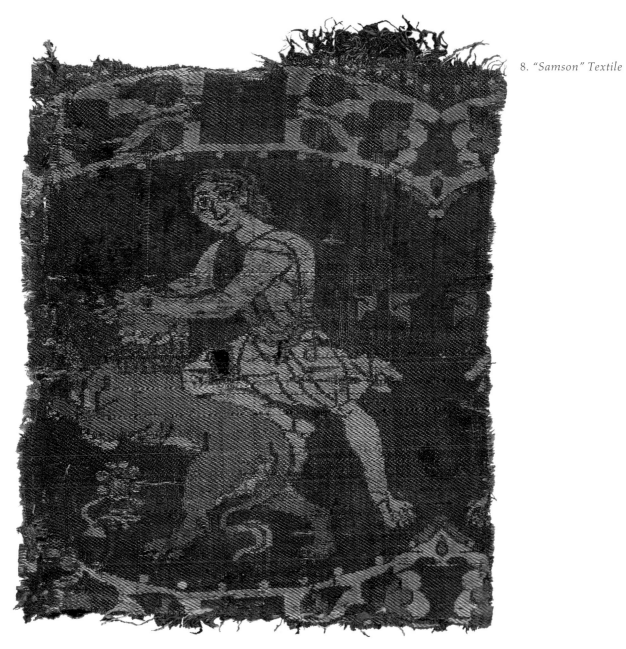

Eugene IV
Gabriele Condulmer
1431–47

Nicholas V
*Tommaso
Parentucelli*
1447–55

Calixtus III
Alfonso Borgia
1455–58

Pius II
*Enea Silvio
Piccolomini*
1458–64

Paul II
Pietro Barbo
1464–71

Sixtus IV
*Francesco della
Rovere*
1471–84

Innocent VIII
*Giovanni Battista
Cibò*
1484–92

Alexander VI
Rodrigo Borgia
1492–1503

Pius III
*Francesco Todeschini-
Piccolomini*
1503

Julius II
*Giuliano della
Rovere*
1503–13

Leo X
Giovanni de' Medici
1513–21

Adrian VI
Adrian Florensz
1522–23

Clement VII
Giulio de' Medici
1523–34

Paul III
Alessandro Farnese
1534–49

Copying and producing books has always been essential to the practice of the Christian faith. Without books, services could not be conducted, laws codified and promulgated, and doctrine espoused. Without books, the written word—the teachings and commandments of God himself, as conveyed in the Gospels and biblical texts—could not be made available to the faithful. From the earliest days of the Church, the copying (and often embellishment) of books went on continuously in scriptoria throughout Christendom. As the intellectual epicenter of the faith, the papacy has historically assumed the greatest responsibility not only for collecting but also for commissioning the production of books.

Such books initially served liturgical and administrative needs. Books and libraries also provided a potent symbol of the moral authority of the Church and, in particular, of the vested authority in the person of Christ's representative on Earth, the pope. During the Renaissance, the papal libraries, now concentrated at the Vatican, became the largest in Europe and included books in all fields of learning and all languages. The Renaissance popes established a tradition of generosity, if at times self-serving, in continuing to endow this library with books and in making its holdings available to scholars. Thus, the Vatican Library has provided a remarkable resource for scholarship since the fifteenth century.

On his election as pope in 1447, Nicholas V discovered in the Vatican 350 codices, primarily Latin texts but also others in Greek and Hebrew, listed in an inventory drawn up by his predecessor, Eugene IV. To this core collection Nicholas V added his own books. He also initiated searches throughout Europe and the Near East to obtain additional books and manuscripts, or copies of them. At his death in 1455, Nicholas V had expanded the papal holdings to some 1,500 volumes, the largest single collection in Europe. It was Sixtus IV, however, who established the formal structure of the Vatican Library and appointed as the first librarian the classical scholar Andrea Bussi. In a bull of 1475, Sixtus IV formally defined the function of the library and set the precedents for its administration.

Beyond their interest in books as purveyors of knowledge or implements for the liturgy, many Renaissance popes saw the edifying value of books, often in terms more artistic than intellectual or spiritual. In an era that placed great emphasis on refined taste, panoply, and grandeur as well as artistic erudition, Renaissance popes commissioned at great expense some of the most spectacular illuminated manuscripts of their day. The embellishment of such books was just as important in the projection of papal majesty as sumptuous vestments and liturgical vessels or furnish-

ings for the Sistine Chapel or the papal apartments. Many of the popes of this era came from great families—the Medici, the Farnese, the Borgias—and were highly educated, groomed in the visual arts, and often had previous collecting histories. For such animated personalities, commissioning great art and beautiful books was a profound statement of personal taste. To these important patrons gravitated many of the most talented book illuminators of the time—Giulio Clovio, Attavante degli Attavanti, Vincent Raymond, and Apollonio de'Bonfratelli, to name a few.

The three masterpieces of Renaissance book illumination in this exhibition are examples of taste and largesse from the papacies of Alexander VI, Leo X, and Paul III. Even at the beginning of the sixteenth century, when the new technical process of movable type and woodblock printing was about to change the face of the book as it had been known for a thousand years, the discerning eye of the pontiff continued to demand the sumptuousness and ostentation of the handmade, illuminated vellum codex. SNF

9. THE CHRISTMAS MISSAL OF POPE ALEXANDER VI

1492–94, FRA ANTONIO DA MONZA AND COLLABORATORS
(ITALIAN, MILAN, ACTIVE IN ROME 1492–1503). INK, TEMPERA, AND GOLD ON PARCHMENT
69 LEAVES, 46.5 X 32.4 (18⅜ X 12¾)
BIBLIOTECA APOSTOLICA VATICANA, MS BORG. LAT. 425

Deliberately ostentatious, this missal was commissioned by Alexander VI to reflect the splendor and magnificence of the office. Among the numerous decorative and scribal references to the pope, the most prominent is his portrait, flanked by his coat of arms, at the bottom of the first page of the Introit (the introductory prayer for the Proper of the Mass). There is also a dedication to him within the manuscript's colophon. Alexander VI was an avid supporter of pontifical ceremony and an eager patron of the arts. His taste for worldly pursuits and the prestige of the office led to the high standards of artistic refinement of which this manuscript is an example.

Missals are fundamental to the celebration of the Mass (the Eucharistic sacrament), during which bread and wine are miraculously transformed into the Body and Blood of Christ. Missals contain the texts necessary for the rite as well as chants, prayers, and readings for recitation by the celebrant, together with ceremonial directions. These service books were used by all clergy, including the pope, throughout the liturgical year. Manuscript missals of the Middle Ages and Renaissance were typically unembellished. Traditional decoration was often restricted to a single miniature in the Canon (the most solemn part of the Mass).

The Christmas Missal of Pope Alexander VI is an exception to this artistic conservatism. The decorative program introducing the Canon features a large miniature of the Crucifixion by the Milanese artist Antonio da Monza, a Franciscan monk whose illuminations strongly suggest the influence of his contemporary, Leonardo da Vinci. In this Crucifixion, Antonio, who would have known Leonardo's painting in Milan, has adopted the older master's craggy landscapes and facial types, especially evident in Saint John. The large historiated initial "T" (*Te igitur clementissime pater. . . .* Therefore, O most merciful father) in which the Elevation of the Host is depicted and the initial "P" (*Puer natus est nobis. . . .* For a child is born to us) with the Nativity on the first page of the Introit, as well as four smaller initials in the missal, could be early works of another illuminator from Milan, Matteo da Milano. Matteo is not known to have been working in Rome during that period, and if these initials indeed are his early work, the missal may not have been produced entirely in Rome. His authorship remains unestablished and problematical, however. The border decoration on the "Te igitur" page, rendered in burnished gold and a sharp acid palette, includes meandering pen flourishes, acanthus sprays, and floral motifs interspersed with Renaissance trappings such as clambering putti, occasional birds, urns, garlands, and emblematic devices such as the bull, the emblem of the Borgia family.

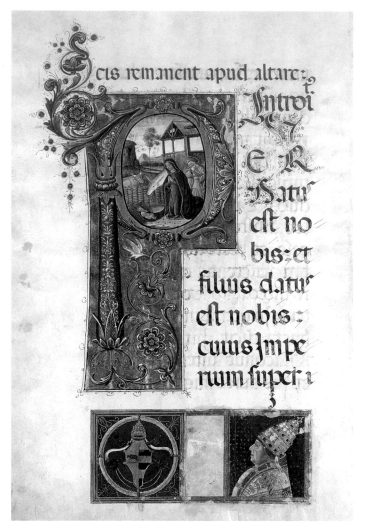

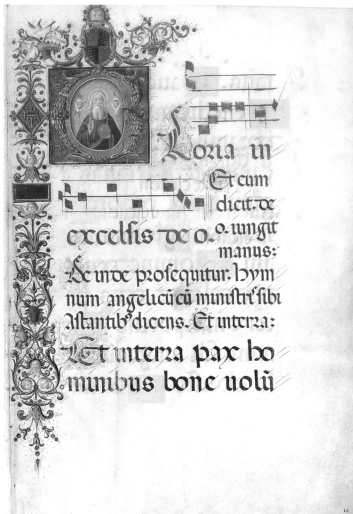

9. The first page of the Introit, showing the Nativity within the letter "P." Folio 8 verso, *The Christmas Missal of Pope Alexander VI*

This manuscript is also unusual in that its texts were intended for a single and specific Mass—the main High Mass celebrated on Christmas morning. Its rubrics include elaborate instructions for the vesting of the pope in the sacristy just before the Mass as well as detailed directives for the performance of the rite itself, including those for assisting clergy such as the deacon and subdeacon. Conventional missals included texts and chants for masses celebrated throughout the liturgical year. During the Renaissance, a tradition was established in which the pope celebrated Mass in Saint Peter's basilica on three major feast days: Christmas morning, Easter, and the Feast of Saints Peter and Paul (29 June). SNF

9a. The first page of the Gloria, showing God the Father within the letter "G." Folio 10 recto, *The Christmas Missal of Pope Alexander VI*

9b. A page from the Canon of the Mass, showing the bull of the Borgia family arms within the letter "H." *The Christmas Missal of Alexander VI*

CONTENTS
Sixty-nine leaves with rubrics, prayers, and notes for celebrating Christmas-morning High Mass in Saint Peter's basilica.

DECORATION
One full-page miniature by Antonio da Monza, two large and four small historiated initials and one portrait miniature of Alexander VI (by Matteo da Milano?), coats-of-arms, numerous decorated initials, and decorated borders consisting of sprays of acanthus with putti, flowers, birds, and animals.

TEXT
By a copyist signing the name "Luca" (folio 68 verso).

REFERENCES
Silvio Maddalo et al., *Liturgia in Figura: Codici liturgici rinascimentali della Biblioteca Apostolica Vaticana*, exh. cat., Vatican Library (Rome, 1995), 251–56, cat. no. 59; Jonathan J. G. Alexander, "Matteo da Milano, Illuminator," *Pantheon* 50 (1992), 32–45; *Biblioteca Apostolica Vaticana: Liturgie und Andacht im Mittelalter*, exh. cat., Erzbischoflisches Diözesanmuseum, Cologne (Stuttgart, 1992), 19, 400–03; Bergman, *Splendor of the Popes*, 16–19, cat. no. 5.; Adalbert Roth, *Missale Pontificis in Nativitate Domini: Das Weinachtsmissale Papst Alexander VI (Cod. Borg. Lat. 425)* (Zurich, 1986).

9c. The *Crucifixion* by Antonio da Monza. Folio 38 verso, *The Christmas Missal of Pope Alexander VI*

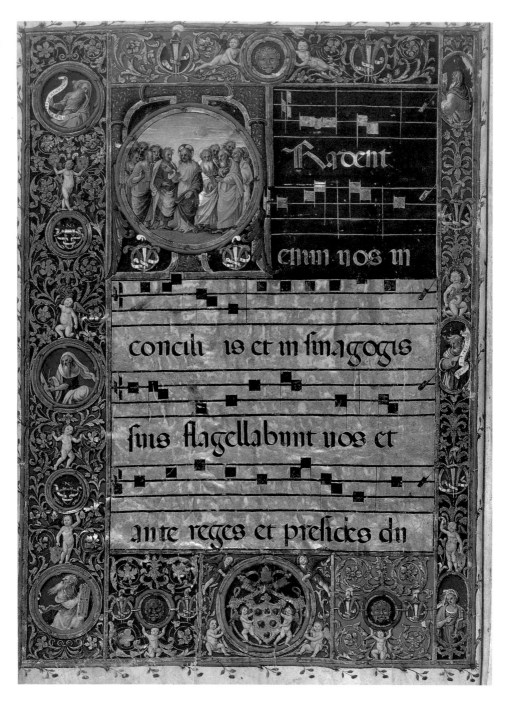

10. The opening text, showing Christ and the Apostles within a decorated border. Folio 2 verso, *Antiphonary of Pope Leo X*

10. ANTIPHONARY OF POPE LEO X

C. 1520(?), ROME. INK, TEMPERA, AND GOLD ON PARCHMENT
93 LEAVES, 57.5 X 41 (22⅝ X 16⅛)
BIBLIOTECA APOSTOLICA VATICANA, MS CAPPELLA SISTINA 10

Leo X had been early destined for the church—tonsured at the age of seven and named cardinal deacon at thirteen. From the illustrious Medici family of Florence, he was the second son of Lorenzo the Magnificent and brought to the papal court a well-nurtured tradition of artistic patronage. Leo X loved literature and fine books and was especially fond of music, toward which his patronage was principally directed. He enjoyed music as recreation in his private apartments and, above all, in the expression and practice of Church liturgy. During his pontificate, Leo X brought to the Sistine Chapel one of the finest moments in its musical history. He revolutionized the organization of the Sistine Choir, then staffed primarily with adult male singers drawn from the North—largely from France, Holland, and Flanders. By the closing of his pontificate, more than half of the twenty singers were Spanish. He also enriched the sound of the choir, which had traditionally sung a cappella, through the addition of wind instruments.

Leo X's endowments to the Sistine Chapel included a series of sumptuously decorated choir books, to which this antiphonary belongs. An antiphonary is a special choral book containing the sung portions of the Divine Office, the cycle of daily devotions meant to be recited (from a breviary or psalter) or sung (from an antiphonary such as this one) by a choir or religious confraternity at eight set intervals each day (the canonical hours). Because these manuscripts were placed on a lectern and had to be read simultaneously by all members of a choir, they were produced in large format with oversized notes and letters that could be seen and read from a distance. Antiphonaries were often embellished with decorated letters and historiated initials meant to provide visual order and quick reference to the saints and key events of the liturgical year. Frontispiece folios in these great books, especially in Italy, received the most decorative attention, frequently with elaborate borders as seen here. The contents of the antiphonary are arranged in accordance with the *Temporale, Sanctorale,* and *Communale* in liturgical order (beginning with Saint Andrew's day, 30 November). The Temporale (Proper of Time) observes Sundays and feast days commemorating the life of Christ (Christmas, the Epiphany, Easter, etc.). The Sanctorale (Proper of the Saints) observes the feast days of the major saints, including those of the Virgin Mary. The Communale (Common of the Saints) commemorates minor and unspecified saints. These three liturgical divisions usually necessitated separate volumes. The *Antiphonary of Pope Leo X* includes the music for the Common of the Saints and thus represents the third volume of a three-volume set.

This manuscript is one of the most beautiful and spectacularly decorated of the Sistine Chapel collection, built up under Leo X and his successors Clement VII and Paul III. The opening folios are a sumptuous visual feast of burnished gold and the predominant hues of indigo and ruby. The opening text is partially inscribed in gold letters, with a large historiated initial "T" (*Tradent enim vos in conciliis. . . .* For they will deliver you up to councils) enclosing a miniature of Christ and the Apostles. The borders are elaborated with gilt acanthus leaves, masks, highly animated putti, and a series of rondels and cartouches enclosing Old Testament figures and saints. In the lower border are the arms of Leo X incorporating the Medici escutcheon (six balls in a three-two-one configuration). Authorship of the large miniature of Christ and the Apostles has not been established, though the thick-set, agitated figures with highly unusual dreamy faces, gesturing hands, and deep-fold draperies owe something to early mannerism. Typically, decoration of this manuscript (and the other two volumes in the set) would have been a collaborative endeavor involving several illuminators.

The spectacular decoration of chant manuscripts in the Sistine Collection shows the high status music enjoyed at the papal chapel in projecting papal majesty. In addition to luxurious choir books, Leo commissioned a set of tapestries from Raphael to decorate the walls of the Sistine Chapel. It has been effectively argued that the existence of these tapestries owes much to the pope's musical sensibilities. Writing in 1549, Paolo Giovio observed that the beneficial acoustical properties of tapestry were well known at Leo's court. SNF

CONTENTS
Ninety-three leaves with chants and notes for the Common of the Saints, the Feast of the Dedication of a Church, and the Office of the Dead.

DECORATION
Three large and numerous small historiated initials, one medallion miniature, two pictorial borders with roundel miniatures, putti, acanthus, and coats-of-arms.

REFERENCES
Maddalo, *Liturgia in Figura*, 186–92, cat. no. 36; Richard Sherr, "Music and the Renaissance Papacy: The Papal Choir and the Fondo Cappella Sistina," in *Rome Reborn: The Vatican Library and Renaissance Culture*, exh. cat., Library of Congress (Washington and New Haven, 1993), 199–213; Bergman, *Splendor of the Popes*, 20–21, cat. no. 6.; *Raffaello nel Vaticano*, exh. cat., Braccio di Carlo Magno (Milan, 1984), 85–88; John K. G. Shearman, *Raphael's Cartoons in the Collection of Her Majesty the Queen, and the Tapestries for the Sistine Chapel* (London, 1972), 12–13.

11. CONSTITUTIONS OF THE SISTINE CHAPEL

1545, VINCENT RAYMOND (FRENCH, ACTIVE IN ROME AT THE PAPAL COURT C. 1513–57)

INK, TEMPERA, AND LIQUID GOLD ON PARCHMENT

60 LEAVES, 36.5 X 25.5 (14⅜ X 10⅛)

BIBLIOTECA APOSTOLICA VATICANA, MS CAPPELLA SISTINA 611

The papal choir had been a distinct institution within the curia since the early fifteenth century and had thus, over time, assumed a bureaucratic structure with specific privileges. Members of the choir became known as the College of Singers and held a document, a constitution outlining the singers' duties, privileges, and code of behavior as well as supplying rules for daily life, both personal and professional. This beautiful manuscript represents the earliest extant constitution for the choir of the Sistine Chapel. It was composed by Ludovico Magnasco, Master of the Sistine Chapel, in response to a bull published in 1545 by Pope Paul III authorizing and approving a new constitution for the Sistine Choir. This manuscript was undoubtedly produced to replace earlier such documents lost in 1527 during the sack of Rome by troops of the Hapsburg emperor Charles V. Given its lavish decoration, dedicatory inscription, and papal portrait, the manuscript was clearly made as a presentation copy for Paul III himself, whose name and arms it bears on its frontispiece.

Paul III was a polished humanist who restored the University of Rome and was an enthusiastic patron of architects and painters alike. He is particularly noted for commissioning from Michelangelo a monumental fresco of the Last Judgment for the end wall of the Sistine Chapel. Like his two predecessors, Leo X and Urban VII, this pope greatly enriched the Vatican Library. The French miniaturist Vincent Raymond, who was responsible for the major illuminations in this manuscript, was appointed papal miniaturist by Paul III in 1549, a post he occupied until his death in 1557.

The manuscript opens with a pair of facing full-page miniatures by Raymond. The first, or verso, miniature represents the kneeling Magnasco presenting the bound manuscript to a seated Paul III. Behind Magnasco are members of the Sistine Choir. All the figures are painted with an attention to detail that suggests portraiture. Incorporated into the painted architectural frame, above, is the pontiff's name, PAVLVS III PONT[IFEX] MAX[IMVS], and, below, the papal coat of arms. The facing, or recto, miniature depicts the Crucifixion in traditional fashion with flanking figures of the Virgin and Saint John and a kneeling Mary Magdalene. The frame incorporates placards with inscribed Latin texts, one of which includes a short prayer or incantation to Christ. The larger placard is inscribed with a lengthy pledge to be recited by the singers involving a vow of obedience to the chapel master (the pope) and adherence to the rules set forth in the constitutions. Indeed, the signatures of the masters of the chapel and many Italian and foreign singers are found within the volume.

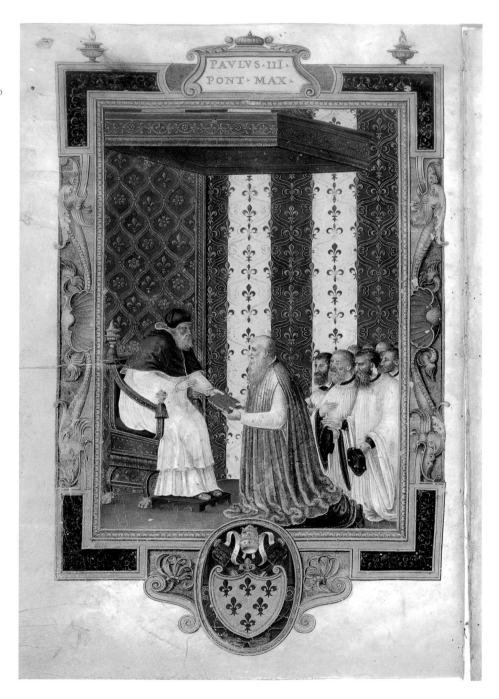

11. The first minia-
ture, showing
Ludovico Magnasco
presenting the
bound manuscript to
Pope Paul III. Folio,
1 verso, *Constitu-
tions of the Sistine
Chapel*

Vincent Raymond's palette includes rich ultramarine blues, acid greens, lavenders, and vibrant reds, all unified by the liberal use of liquid gold. During his long career in Rome, Raymond worked for three successive popes and, as is evident in his mannered figural style, readily absorbed the monumental art of the Roman milieu, particularly that of Raphael and Michelangelo. Yet Raymond's striking use of highly symmetrical architectural framing devices owes more to French manuscript painting than to the influence of Italian contemporaries such as the illuminator Giulio Clovio, who also worked at the papal court of Paul III. The use of architectural frames in conjunction with text placards had been formulated in France a century earlier by Jean Fouquet and his followers at Tours. This convention established the illusionistic effect of a window aperture or a "stage" and tended to exaggerate spatial recession. While ornamental frames were commonly used by Italian illuminators in liturgical, devotional, and humanistic manuscripts, Raymond's frames include particular ornamental elements such as addorsed dolphins, marbleized panels, scallop shells, burning urns, and egg-and-dart borders—all commonly found in French royal manuscripts of the Fontainebleau School. These works include, for example, the *Hours of Henri II* (Bibliothèque Nationale, Paris) and the *Hours of Anne de Montmorency* (Musée Condé, Chantilly) and suggest that Raymond remained very much aware of book fashion in his native France. Raymond produced another manuscript for Pope Paul III, a luxury psalter (Bibliothèque Nationale, Paris).

SNF

CONTENTS

Sixty leaves.

DECORATION

Two full-page miniatures by Vincent Raymond within architectural Fontainebleau-style frames; numerous large and small decorated initials.

REFERENCES

Maddalo, *Liturgia in Figura*, 202–5, cat. no. 41; Sherr, "Music and the Renaissance Papacy," 199–213; Bergman, *Splendor of the Popes*, 22–23, cat. no. 7; *Fifth Centenary of the Vatican Library, 1475–1975*, exh. cat., Vatican Library (Rome, 1975), 113, cat. no. 269.

Julius III
*Giovanni Maria
Ciocchi del Monte*
1550–55

Mark II
Marcello Cervini
1555

Paul IV
Gian Pietro Carafa
1555–59

Pius IV
*Giovanni Angelo
de' Medici*
1559–65

Saint Pius V
Antonio Ghislieri
1566–72

Gregory XIII
Ugo Buoncompagni
1572–85

Sixtus V
Felice Peretti
1585–90

Urban VII
*Giambattista
Castagna*
1590

Gregory XIV
Niccolò Sfondrato
1590–91

Innocent IX
*Giovanni Antonio
Facchinetti*
1591

THE NEW SAINT PETER'S AND VATICAN CITY

T HE AREA ON WHICH SAINT PETER'S and Vatican City were built on the west bank of the Tiber River reached from the Janiculum (one of the seven hills of Rome) in the south to the Milvian Bridge in the north and was called Vaticanum (a word probably of Etruscan origin) by the ancient Romans. In the third century a monument commemorating the tomb of Saint Peter, who was crucified nearby in the Circus of Nero, was erected on this site. The tomb itself was probably also nearby. Many Christian family tombs were built in this immediate area, and Saint Peter's monument was given special importance among them when it was erected. In AD 320–330 the emperor Constantine ordered a church built on the site. After the Saracen invasions destroyed much of the area in the ninth century, Leo IV built great walls (some still standing) to protect the sacred shrine.

The old Constantinian basilica of Saint Peter's, which commemorated the saint's martyrdom, was embellished and restored for more than a millennium until it became obvious that a new basilica was needed to replace the decaying structure. The Vatican palaces also grew over a period of years. Although at one time there were gardens and a summer palace at the old Saint Peter's, the popes' residence was next to San Giovanni in Laterano, the cathedral church of Rome. However, in the fifteenth century, the popes transferred their residence to the Vatican.

The drawing, print, and letter in this section illustrate the architectural changes taking place at the Vatican in the mid-sixteenth century during the construction of Saint Peter's basilica, the largest primary church in Christendom. DDG

12. *The Construc-
tion of Saint Peter's
Viewed from the
Southwest*

12. THE CONSTRUCTION OF SAINT PETER'S VIEWED FROM THE SOUTHWEST

AFTER MAY 1545, ANONYMOUS (FLEMISH). PEN AND BROWN AND RED INK
29.9 X 43.8 (11¾ X 17¼)
BIBLIOTECA APOSTOLICA VATICANA, DISEGNI ASHBY, 330

Typical of sixteenth-century northern drawings in its accurate rendering of a specific site, this sheet is also significant for its evocation of the atmosphere and architecture of Renaissance Rome. The drawing is a crucial document of the building of Saint Peter's basilica and the description of earlier buildings no longer extant. Numerous northern artists visited Rome in the sixteenth century and filled sketchbooks with views of ancient and contemporary monuments. These drawings have become vital records of the rapid architectural changes that took place in the papal city.

The artist who created this sheet took this oblique view of Saint Peter's from the southeast, perhaps from the Collegio dei Penitenzieri or the Palazzo Cesi. In the foreground are houses that were later destroyed by Gian Lorenzo Bernini for the enlargement of Saint Peter's Square. The loggias in the middle ground are those of the Palazzo dell'Arciprete (left) and the fifteenth-century Benediction Loggia. To the right of the loggia is the palace of Paul II, behind which is the roof of the Sala Regia. The Sistine Chapel and the campanile (bell tower) are seen toward the right in the background, partly hidden by the loggia. The campanile is shown without the pointed spire that was built over the medieval tower. Construction of the spire was begun by Antonio da Sangallo the Younger in May 1545 (in 1571 it was changed to a domed top).

Between the Palazzo dell'Arciprete and the Benediction Loggia is the façade of the old basilica of Saint Peter's, soon to be demolished. In the center background, at left, is the construction of the crossing of the new Saint Peter's. To the left of the nave of old Saint Peter's is the *divisorio*, the dividing wall built in 1538 to separate the new construction from the still-functioning old basilica. To the left of the construction is the rotunda of the church of Santa Maria delle Febbre and the Egyptian obelisk, later moved to Saint Peter's Square by Sixtus V. The walls in the far background at left are those built by Leo IV during the ninth century.

Because of the state of construction of Saint Peter's, the drawing can be dated to 1545 when Sangallo's transept was being built and, it would seem at first, before he added the spire to the campanile. At that time,

prior to his death, the foundations and part of the transept were completed. The Flemish inscription on the drawing, however, situates it chronologically to May 1545 or after, when the spire of the campanile was built. The inscription above the bell tower, *toren gaet nie* (the tower does not work), indicates that the artist could not fit the tower in the drawing and decided to leave it out. There are slight traces of the outlines of a tower, which, if fully drawn, would have gone beyond the upper edge of the paper.

The drawing does not belong to the Thomas Ashby collection, purchased for the Vatican Library in 1933, but was a gift to Pius XI the same year from the Istituto Farmacologico Serono, Rome. DDG

REFERENCES
Giovanni Morello, ed., *Vatican Treasures: 2000 Years of Art and Culture in the Vatican and Italy,* exh. cat., Colorado History Museum (Denver, 1993), 161, cat. no. 52; Christoph Frommel in *Raffaello in Vaticano,* 162, cat. no. 70; Didier Bodart, *Dessins de la collection Thomas Ashby à la Bibliothèque Vaticane* (Vatican City, 1975), 113–14, cat. no. 330; Hermann Egger, *Römissche Veduten: Handzeichnungen aus dem XV.–XVIII. Jahrhundert* (Vienna, 1911), 1:25–26, pl. 20.

Old Saint Peter's basilica, like all seats of religion, was continually restored from the time of its construction. False starts in constructing a new Saint Peter's began in the fifteenth century. Finally, Pope Julius II hired Donato Bramante (1444–1514), who designed a building with a cross plan of grandiose scale, begun in 1506. After his death, Bramante was succeeded by Giuliano da Sangallo, Fra Giocondo, and Raphael, but little construction was accomplished for several decades because of the successive deaths of the architects and the devastating sack of Rome in 1527, when Italy was caught in the middle of the war between the German emperor Charles V and the French king Francis I. Antonio da Sangallo the Younger had supervised the construction, what little there was, after 1520. Paul III took up the challenge to continue construction in 1536, retaining Sangallo in the role of architect. Sangallo, a Florentine who had trained with his uncle Giuliano, was Raphael's assistant in Rome when he was architect of Saint Peter's. Sangallo worked for the Farnese family, designing their palace, which was completed by Michelangelo. Upon Sangallo's death in 1546, Michelangelo succeeded him as architect of the basilica.

Sangallo's progress and plans for the basilica are well documented by contracts, letters, prints, and a large wooden model built under the supervision of Antonio Labacco, his assistant. Yet despite the building activity that took place before his death, little remains of Sangallo's church. He had changed Bramante's design from a central plan to a compromise between a central and a cross-shaped church. The complex project is seen in engravings that derive from the immense wooden model. This engraving of the elevation of the façade was published in 1548. It bears the coat of arms and papal tiara of Paul III above and the official papal approval granting publication at bottom. The façade of the basilica, as can be seen, was to be a complex articulated front that reiterated the interior plan. Bell towers arise at either side to the same height as the elaborate, richly designed dome. They reinforce Sangallo's debt to the Middle Ages, but contrast with the more ovoid, classical shape of the dome. With these elongated towers Sangallo attempted to give a soaring upward thrust to the heavy horizontal façade. The three-story façade is broken down longitudinally into separate portals for the main entrance and the bell towers. Arched and rectangular windows alternate along the heavily encrusted front. Sangallo's influence of classical forms is found in the numerous variations of the antique orders, fragmenting the horizontality of the long façade. The result is a squat Gothic cathedral articulated by classical orders. Behind the façade were three naves with side chapels and

*13. Façade of Saint
Peter's Basilica*

ambulatories in the cross arms and apse. When Sangallo died, he had completed the barrel vaults on the east and south and the outer wall of the southern apse up to the first story.

The façade and dome as seen in Sangallo's plan were not completed as such by his successor, Michelangelo, who criticized his predecessor's church as being too large, too dark and dangerous, and too complicated. He returned to Bramante's cross-shaped plan and rejected the ambulatories that Sangallo added. The façade as built closely reflects not Sangallo's plan as seen in the engraving but a mixture of the designs of Michelangelo and Carlo Maderno (1556–1629), who became architect of the basilica in 1604. Gone is the complicated articulation, replaced by wider bays and only two stories. The confusion among the numerous portals has disappeared in favor of alternating pilasters and windows. Michelangelo made the façade more imposing by erecting tall pilasters that unified the stories and monumentalized both the horizontal and vertical articulation. However, Maderno added a prominent central portico to encompass the required Benediction Loggia. Michelangelo's dome, which essentially was built as designed, contains paired columns and windows. Sangallo's dome is more vertical, combining medieval and classical elements. Sangallo's basilica, in contrast to the final building, appears retardataire and overly embellished. Yet its ambition and strength live on in the wooden model and the engravings that immortalize it. DDG

REFERENCES
Sandro Benedetti in *The Renaissance from Brunelleschi to Michelangelo: The Representation of Architecture,* edited by Henry A. Millon and Vittorio Magnago Lampugnani, exh. cat., Palazzo Grassi (New York, 1994), 631–33; Angelandreina Rorro in Morello, *Vatican Treasures,* 83, 161, cat. no. 53; *Antonio da Sangallo il Giovane: La vita e l'opera,* Acts of the 22nd Conference on History and Architecture (Rome, 1986); Suzanne Boorsch, "The Building of the Vatican: The Papacy and Architecture," *Metropolitan Museum of Art Bulletin* 40 (Winter 1982–83).

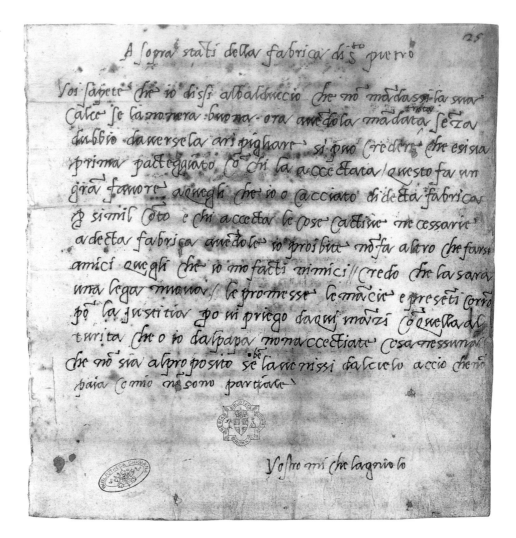

To the superintendents of the Fabbrica di San Pietro

As you know, I asked Balduccio [Jacopo Balducci] not to send his lime if it was not of excellent quality. Now, since he has sent bad quality lime, he should certainly come and take it back. It is easy to see that he had previously made an agreement with whoever accepted it; this person does great favors for those whom I have already sent away from the site, telling them not to come back, and he does nothing but befriend those who are my enemies. I am of the opinion that they are all in league. Promises, gratuities, and gifts pervert the course of justice: thus, with the authority the pope has bestowed on me, I implore you from now on not to accept anything that does not serve our purposes, even if it comes from Heaven itself, so that I should not appear—as indeed I am not—in any way partial.

Your Michelagniolo

14. LETTER CONCERNING WORK ON
SAINT PETER'S BASILICA

C. 1550–53(?), MICHELANGELO BUONAROTTI (ITALIAN, 1475–1564). BROWN INK ON PAPER
22.5 X 20.5 (8⅞ X 8⅛)
BIBLIOTECA APOSTOLICA VATICANA, CHIG. H II 22, F. 25

Michelangelo had worked in the Vatican for Julius II (the Sistine Chapel ceiling and his papal tomb) and returned to paint the *Last Judgment* in the chapel for Paul III in 1543. Paul III asked Michelangelo to take over as the chief architect of the basilica of Saint Peter's after the death of Antonio da Sangallo in 1546. Michelangelo reluctantly agreed and remained as architect until his death in 1564. During that time, he changed Sangallo's design, which he believed represented a bastardized classicism. The final plan, cupola, and exterior articulation can be credited largely to Michelangelo's design.

In accepting the assignment from Paul III, Michelangelo insisted on complete autonomy. This letter reflects the artist wielding the power vested in him. It is written to the "Fabbrica" of Saint Peter's, that is, the officials in charge of building and maintaining the basilica. Like any good architect, he demanded proper materials. Critical of Sangallo's design, Michelangelo was also critical of all the workers from the Sangallo camp, whom he dismissed when he believed them to be dishonest. The letter suggests as well Michelangelo's dedication to the project, on which he worked almost constantly after 1550. Physically infirm but mentally powerful, the artist was forced to defend himself before some of the deputies of the Fabbrica, Sangallo's supporters who believed Michelangelo had "ruined" Saint Peter's by giving too little light in the nave. He retorted to the cardinals that it was their job to raise money to safeguard the project from thieves, that he was obligated only to the pope, and that others had to trust him as the responsible technician he was. Michelangelo's authority as architect was not undermined. The result is the beauty of the monumental basilica of Saint Peter's, little changed from his plan after his death. DDG

REFERENCES
Renato Della Torre, *Vita di Michelangelo: L'uomo, l'artista* (Florence, 1990); Paola Barocchi and Renzo Ristori, eds., *Il carteggio di Michelangelo* (Florence, 1979), 4:360; Rorro in Morello, *Vatican Treasures*, 159, cat. no. 49.

Clement VIII
*Ippolito
Aldobrandini*
1592–1605

THIS SERIES OF VESTMENTS produced for the Sistine Chapel were presented to Pope Clement VIII by Ferdinand I de' Medici (1549–1609), grand duke of Tuscany. The gift had been conceived by Francesco I (1541–1587), Ferdinand's brother, who as grand duke had promised to give a series of tapestries to Pope Gregory XIII. Wishing to replace Raphael's "happier" tapestries in the chapel with more solemn ones to be displayed specifically during Advent and Lent, Gregory XIII reminded the Medici of the promise in 1577.

Giorgio Vasari (1511–1574) was to create cartoons for seven tapestries of the Passion to hang in the chapel, but this commission seems not to have gone very far. Later, when Ferdinand became grand duke at his brother's death in 1587, he reinstated the commission but this time as vestments and coverings for the chapel. Alessandro Allori (1535–1607), official painter of the Medici court, designed the cartoons for the tapestries to be woven at the Medici tapestry works, overseen by Guasparri di Bartolomeo Papini (died 1621), the Medici's chief weaver from 1587 to 1621. A Florentine, Allori trained in the shop of the mannerist artist Agnolo Bronzino (1503–1573) and was largely influenced by the work of Michelangelo (1475–1564), whose figures he attempted to emulate, and by Vasari, whose decorative style he adopted. Allori's involvement with the Medici court required him to be conversant in fresco decoration and tapestry design, and he had participated in the design of tapestry cartoons in Bronzino's workshop. In 1575 Allori became the official cartoonist of the Medici tapestry works (the Arazzeria Medicea). Established in 1554, the Arazzeria Medicea became the largest surviving tapestry workshop in Italy.

Documents for the commission of the Sistine Chapel vestments indicate that meetings were held in 1592 to decide on iconography and cost, that the precious gold and silver threads were purchased and work began in 1593, that Allori delivered his last completed cartoons by 1595, that the garments were finished by 1600, and that the set was sent to Rome in 1602. Today the set consists of an altar frontal, cope, chasuble, two dalmatics, a stole, maniple, veil for the chalice, case for the corporal, three missal covers, and a morse. The set was completed by another maniple, two pillows for kneeling, two book pillows, an episcopal seat, and six surplice cases, now lost.

Normally, liturgical vestments were made of woven materials other than tapestry. The complicated working and the use of tapestry indicates the importance of the vestments' destination: a papal chapel. The precious silk and gilt-silver threads and the survival of almost the entire set

give the vestments a unique significance. The Vatican tapestries proudly bear the coats of arms of the Medici and the princes of Lorraine, indicating that the gift came also from Ferdinand's wife, Christine of Lorraine. Above the Medici arms with the ducal crown are those of the Aldobrandini family, appropriately larger and adorned with the papal tiara. In some cases, the dual Medici/Lorenese arms replaced earlier Medici arms and, in others, the Aldobrandini arms replaced single Medici arms. On Ferdinand's orders (probably anticipating a change in papacy at the possible death of the pontiff), the papal arms were inserted after the tapestries were completed, immediately before the gift was presented.

Scholars suggest that the complex nature of the subject matter of the vestments derives from a program conceived by a theologian, perhaps Ferdinand, who was a former cardinal. The solemn theme, with its references to the Passion of Christ, indicates that the garments were worn primarily during Holy Week ceremonies. The limited use of the vestments and their importance as Sistine Chapel decorations account for their remarkable preservation and still vivid colors. Possibly the last pontiff to wear the vestments was Benedict XIII in 1726. The vestments were restored in 1978 and 1981. They were first shown in a Roman exhibition of sacred art in 1870. DDG

REFERENCES
Simona Lecchini Giovannoni, *Alessandro Allori* (Turin, 1991), 276–77, cat. no. 122 (with complete bibliography); Fabrizio Mancinelli in Morello, *Vatican Collections*, 72–79, cat. nos. 25A–M; Erik M. Zafran in Bergman, *Splendor of the Popes*, 24–41, cat. nos. 8–20; Angelica Frezza, "Documenti fiorentini per il parato di Clemente VIII," *Paragone* 33(2), no. 391 (1982), 57–75 (with documents on the commission of the tapestries); Cosmio Conti, *Ricerche storiche sull'arte degli arazzi* (Florence, 1876), 58–60.

15. ALTAR FRONTAL

1593–95, GUASPARRI DI BARTOLOMEO PAPINI (DIED 1621)
AFTER CARTOON BY ALESSANDRO ALLORI (1535–1607)
TAPESTRY IN SILK WITH GILT-SILVER THREADS; 101.9 X 358.5 (40⅛ X 141⅛)
BIBLIOTECA APOSTOLICA VATICANA, MUSEO SACRO, 2780

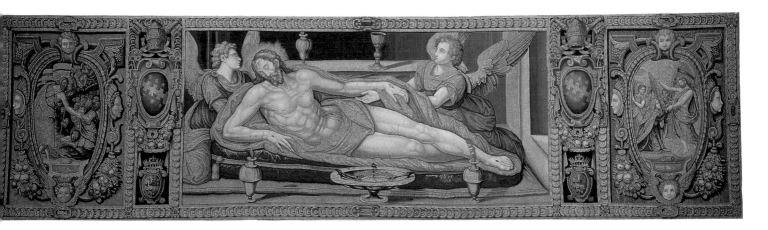

Altar frontals were used widely in the Renaissance, and the most common iconography was that of the dead Christ usually seen, as here, on the Holy Shroud, his burial garment. While the reclining body represented the dead Christ as if in a tomb below the altar, it also suggested his imminent resurrection on Easter Sunday. The traditional portrayal of Christ supported by angels appeared not only on altar frontals but also in numerous paintings, and dates from the Byzantine period. Christ is depicted here as the subject of the Sacrifice of the Mass and as the embodiment of the Eucharist, his body given up for the faithful. Behind him on an altar are a ciborium, the vessel that holds the Eucharist (the Body of Christ), and the chalice that holds wine (the Blood of Christ). Before him in the basin lie two instruments of the Passion: a crown of thorns and the nails that held him to the cross. As the pope celebrated Mass on the altar, the frontal reminded him of Christ as the subject of the Mass.

Flanking the iconic central scene are episodes from Christ's life. At left, portrayed traditionally, is the Descent into Limbo. At right is Christ appearing to his mother, Mary, after the Resurrection, replacing the usual subject of Christ encountering Mary Magdalene *(Noli me tangere)*. Scholars correctly suggest that Mary is represented in this chapel because of its dedication to her Assumption. Traditional strapwork surrounds the scenes and the cartouches are adorned with angelic heads, masks, and boughs of fruit, relieving the severity of the central panel. At the upper corners of the cartouches are bunches of grapes, symbolizing the transformation of wine into the Blood of Christ at the Consecration in the Mass. Typical of Lenten and Easter iconography, the altar frontal was displayed on Holy Thursdays until the end of the nineteenth century.

Allori had employed the same composition in a wall painting in the chapel of the Palazzo Salviati in Florence, executed between 1578 and 1580. He reused the popular motif several more times in small devotional paintings on copper in the 1590s.

The coat of arms of the Aldobrandini with the papal tiara supplanted an earlier coat of arms of the Medici and the princes of Lorraine surmounted by the ducal crown. The Medici arms had replaced an even earlier, unidentifiable coat of arms that had been cut away. The grand duke may have wished to emphasize his commission of the tapestries and thought better of it, diplomatically giving pride of place to the papal arms. The subject of the altar frontal was chosen 31 May 1595 and the tapestry completed by 6 June 1595. DDG

16. COPE

1593–1600, GUASPARRI DI BARTOLOMEO PAPINI (DIED 1621)
AFTER CARTOON BY ALESSANDRO ALLORI (1535–1607)
TAPESTRY IN SILK WITH GILT-SILVER THREADS; 151.3 X 319.1 (59½ X 125⅝)
BIBLIOTECA APOSTOLICA VATICANA, MUSEO SACRO, 2773

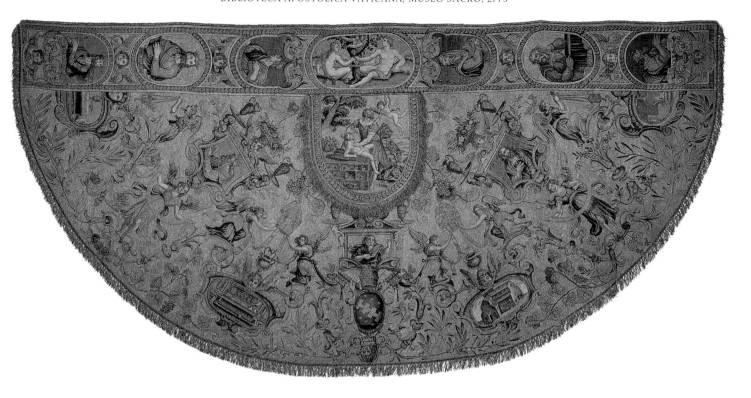

The cope is the heavy semicircular cape worn by the priest over other vestments for processions on solemn occasions. It is fastened in front by a morse (clasp). Allori designed the cope and other vestments according to the contemporary decorative style seen on the ceilings of Roman churches and palaces, including the Vatican. Influenced by the *grottesche* (of the grottoes) of the school of Raphael (the word "grottesche" stems from the style of Roman decoration unearthed during the Renaissance), these decorations depicted diverse scenes in varied cartouches held together on colored backgrounds by connecting branches, boughs, and leaves. Frescoed and tapestry grottesche were the dominant Italian ornamental style in the second half of the sixteenth century. In 1581 Allori had painted a series of grotesques for the Uffizi in Florence and was well aware of their decorative attraction.

Interspersed among the scenes are symbolic figures and forms that appear at first to be purely ornamental but certainly carry deeper meaning. The large ornamental semicircle trompe l'oeil tapestries of this elaborate cope integrate cartouches (some partly hidden under the orphrey, or ornamental band) and kneeling angels who hold the papal tiara, banderoles, and censers. All are secondary to the main narratives of the Sacrifice of Isaac (Genesis 22:1–14) on the central hood and the scene of Original Sin

(Genesis 3:6) above in the orphrey. Below the Sacrifice of Isaac is a bust of Melchizedek. To the right of the scene of Original Sin are the half-length figures of Jacob (Genesis 25:25), his son Juda (Genesis 29:35), and grandson Phares (Genesis 38:29). Phares's son Hesron (1 Chronicles 2:5) is depicted in the cartouche at right on the main part of the cope. To the left of Adam and Eve are David (1 Samuel 17:12), his son Solomon (1 Kings 1:12), and grandson Roboam (1 Kings 11:43). Roboam's son Abia is pictured in the cartouche on the main portion of the cope at left (1 Chronicles 3:10).

The complex imagery of the vestment alludes to the sacrifice of Christ at the Mass by representing specific episodes in the Old Testament that presage his life and crucifixion. Adam and Eve's transgression caused humankind's removal from the Garden of Eden and the shame of sin that only baptism could remove and Christ's sacrifice redeem. The busts of the ancestors of Christ represent the connection between the Old and New Testaments. Jacob was the father of the Hebrews, and David was the patriarch of the family into which Christ was born. The Sacrifice of Isaac and the figure of Melchizedek refer to Christ's sacrifice: one his bloody death on the cross, the other the reenactment of the sacrifice at Mass. Isaac offered his son as sacrifice; the priest Melchizedek offered bread and wine as sacrifice. Thus, the theme of the Eucharist and Christ's sacrifice at the Mass are the real subjects of the cope.

Allori often reused his designs. The Sacrifice of Isaac on the hood of the cope reproduces the composition of a small painting on copper of the early 1570s.

Allori was paid for the cartoon for the cope on 1 January 1594. During conservation of the Medici vestments in 1980–81, it was discovered that the cope's two coats of arms (Aldobrandini and Medici/Lorraine) replaced one large Medici coat of arms. DDG

17. CHASUBLE

1593–1600, GUASPARRI DI BARTOLOMEO PAPINI (DIED 1621)

AFTER CARTOON BY ALESSANDRO ALLORI (1535–1607)

TAPESTRY IN SILK WITH GILT-SILVER THREADS; 140 X 101.9 (55⅛ X 40⅛)

BIBLIOTECA APOSTOLICA VATICANA, MUSEO SACRO, 2769, 2730

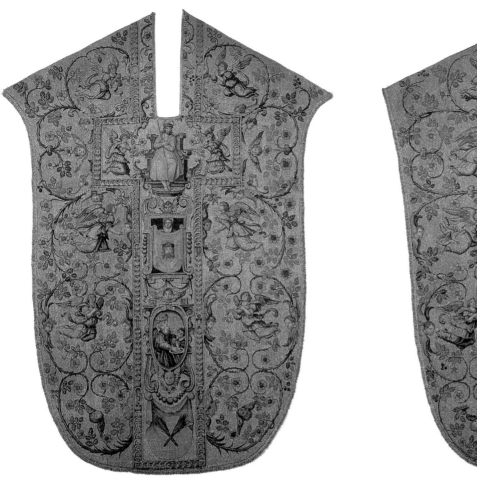
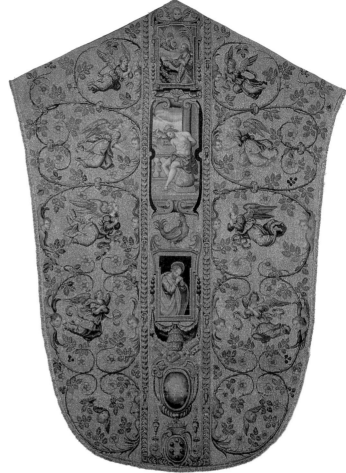

The chasuble is the main sleeveless outer garment worn by priests while officiating at Mass. This one is decorated with two orphreys (the rectangular bands found on liturgical vestments and cloths). Both sides of the garment contain scenes with events from Holy Week, the last week of Christ's life. On the cross-shaped orphrey on the front, Christ is seated on a throne, wearing the crown of thorns and carrying the scepter given him by Pontius Pilate when he declared "Behold the Man" (John 19:5). Surrounded by angels, Christ is given the prominence of an earthly king. Below is one of the stations of the cross: the legendary figure of Veronica holding the veil with which she is said to have wiped Christ's face, leaving his image indelibly printed on the cloth. The third and last representation is of Pilate washing his hands in a basin held by a young boy (Matthew 27:24). At the bottom are the flagella (sticks) the soldiers used to whip Christ.

The back of the chasuble represents three further scenes as well as the papal and Medici coats of arms at bottom. At the top is Christ on the Mount of Olives. As an angel presents him with a chalice, Christ invokes, "Father, if thy be willing, remove this cup from me. Nevertheless, not my will, but thy will, be done" (Luke 22:42). A cock separates this scene from the one below, which depicts a grieving Peter, repentant for having betrayed Christ on the third cry of the cock (Matthew 26:69–75). Several images on the main part of the cope may refer to the Sorrowful Mysteries of the Rosary, which relate the chasuble subtly to Christ's mother, to whom the chapel is dedicated. The chasuble itself is embellished with adoring angels and cherubim flying within decorative entwined flowering brambles, symbolic of the Virgin Mary's purity. Like the burning bramble bush of Moses, she was not consumed by lust but bore the flames of divine love. The angel who offers Christ the chalice on the Mount of Olives alludes to the Eucharist. The representation of Peter, the first pope, was certainly chosen as the precursor of Clement VIII, for whom this vestment was made.

The fronts and backs of the chasuble and dalmatics were separated, probably in 1870 for the Roman exposition, so that both sides could be seen simultaneously. DDG

18. DALMATIC

1593–1600, GUASPARRI DI BARTOLOMEO PAPINI (DIED 1621)
AFTER CARTOON BY ALESSANDRO ALLORI (1535–1607)
TAPESTRY IN SILK WITH GILT-SILVER THREADS; 135.3 X 146.1 (53¼ X 57½)
BIBLIOTECA APOSTOLICA VATICANA, MUSEO SACRO, 2777

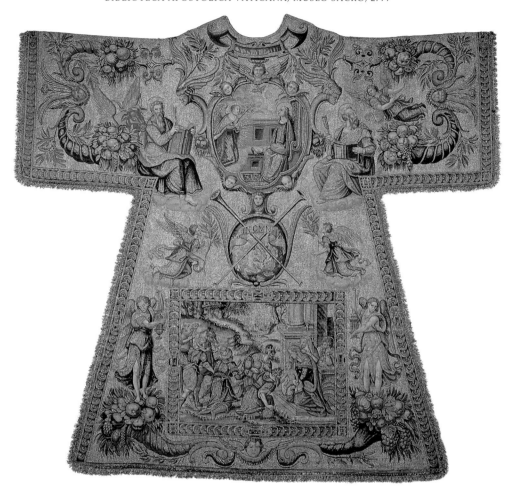

Dalmatics are short-sleeved tunics worn by priests under the sleeveless chasuble and by deacons as their main garment during the celebration of the Mass. On this Vatican dalmatic various scenes from Christ's life are enframed in cartouches. Cornucopia filled with fruit (symbolizing abundance) including grapes (symbolizing Christ's blood) distinguish the corners, cherubim surround the cartouches, flying angels carry olive branches and palms, and standing angels wave incense censers. The four evangelists, the New Testament narrators of the events in Christ's life, sit at either side of the narrative scenes at top. Below the scene on the front is an earthly globe, with crossed trumpets. The "in omne" could be from Psalm 18 (5): *in omnem terram exivit sonus eorum* (their sound has gone forth into all the earth).

The upper scene on the front represents the Annunciation to the Virgin. The angel Gabriel at left flies toward Mary carrying lilies, symbolizing purity, while the Holy Ghost in the form of a dove hovers above (Luke 1:28–35). Unusual in the depiction is that Mary is sitting on a

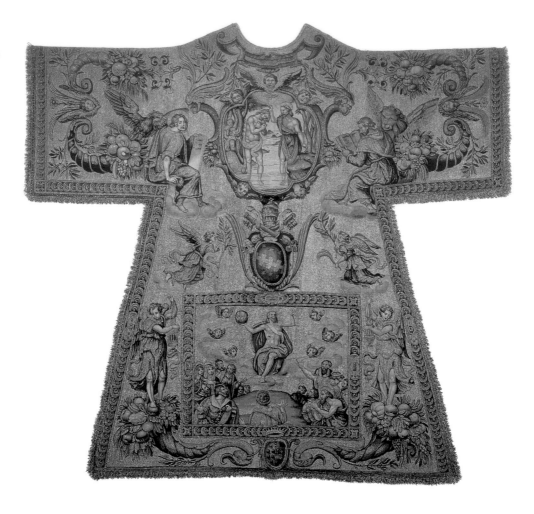

throne rather than kneeling in a chapel, implying her importance as the future queen of heaven. The other large horizontal scene below depicts the Adoration of the Magi (Matthew 2:11), with a procession-like composition of Venetian inspiration. The two Mariological scenes are appropriate both as early episodes in Christ's life and as depictions on vestments to be worn in the chapel dedicated to Mary's Assumption. The evangelists represented at top are Luke (at left, with his attribute, the ox) and Matthew (at right, with his attribute, an angel).

Scenes from Christ's life decorate the back. At the top is the Baptism of Christ in the river Jordan by John the Baptist (Mark 1:9) and below is the Ascension of Christ (Luke 24:51). These particular scenes suggest that salvation (by Christ's sacrifice and Resurrection) is gained through baptism. At either side are the evangelists John (with his attribute, the eagle) and Mark (with his attribute, the lion). Scholars suggest that the appearance of the evangelists on the dalmatic may indicate that the vestment

was worn by the deacon, whose role was to read from the Gospels. The Gospel, the last lesson read at the Mass because it evokes the supremacy of the New over the Old Testament, is usually read by the deacon, at the right (north) side of the altar.

In the Adoration of the Magi on the front, Allori repeated his earlier, more elaborate tapestry composition for Santa Maria Maggiore in Bergamo of 1583. The Ascension scene on the back was used earlier in a small painting on copper of c. 1581. DDG

19. DALMATIC

1593–1600, GUASPARRI DI BARTOLOMEO PAPINI (DIED 1621)
AFTER CARTOON BY ALESSANDRO ALLORI (1535–1607)
TAPESTRY IN SILK WITH GILT-SILVER THREADS; 134 X 147 (52¾ X 57⅞)
BIBLIOTECA APOSTOLICA VATICANA, MUSEO SACRO, 2727, 2731

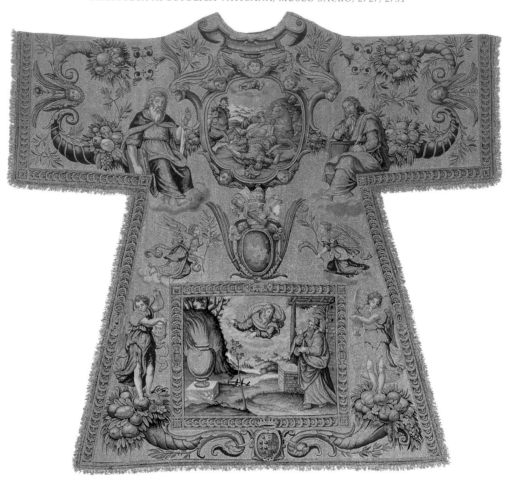

While both deacons and subdeacons wore dalmatics, these important Vatican vestments may have been worn only by deacons. Fashioned to complement the previous dalmatic in design and composition, this garment represents not scenes from Christ's life but contrasting episodes from the Old and New Testaments. On the front at top is Christ Giving the Keys to Peter (John 21:15–17), the first pope, thus instituting the Church. The lower scene represents Isaiah Healing Hezekiah (2 Kings 20:1–11; Isaiah 38:1–22). At either side of the upper scene are Peter at left and Isaiah at right. As on the previous dalmatic a globe with the passage from Psalm 18 (5) flanked by angels with olive branches is placed in the center of the vestment.

The scenes on the back represent, above, the Conversion of Saint Paul (Acts 9:3–9) and, below, the Flowering of the Rod of Aaron (Numbers 17:8; Hebrews 9:4). Seated at either side of the scene above are Paul, at left, and Aaron, at right. The subjects complement those of the fifteenth-

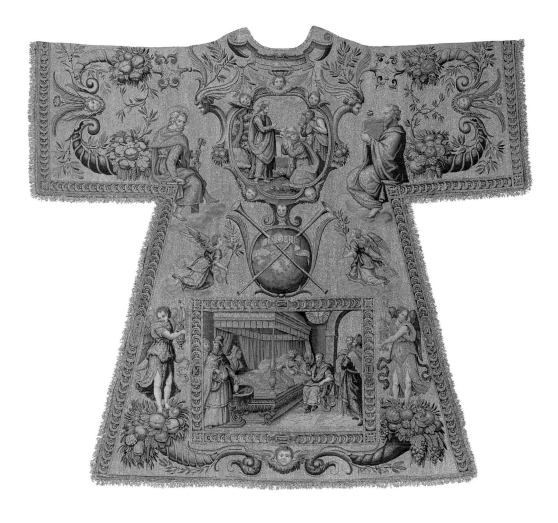

century fresco cycle in the Sistine Chapel: the Old Testament prophecies of the coming of Christ and the establishment of his Church. Whereas the frescoes compare and contrast the life of Moses with that of Christ, the scenes on the vestments expand the repertoire to include other prophecies of Christ's coming. A few of the scenes overlap, however, such as the Baptism, the Last Supper, Christ's Charge to Peter, and the Ascension. Unlike the frescoes, which have few references to the Virgin Mary, to whom the chapel is dedicated, there are numerous references to her on the vestments.

Because Saint Paul's epistles to the Romans and the Hebrews emphasized the supremacy of the new law over the old, scholars believe that this dalmatic was worn by the deacon assigned to the reading of the Epistle at Mass. Epistles were official letters, usually sent to congregations in order to express theological doctrine. In the Mass, the Epistle precedes the Gospel and is read on the left (south) side of the altar, normally by the subdeacon. DDG

20. STOLE

1593–1600, GUASPARRI DI BARTOLOMEO PAPINI (DIED 1621)
AFTER CARTOON BY ALESSANDRO ALLORI (1535–1607)
TAPESTRY IN SILK WITH GILT-SILVER THREADS; 231.1 X 13 (91 X 5⅛)
BIBLIOTECA APOSTOLICA VATICANA, MUSEO SACRO, 2776 A–B

Stoles, worn under dalmatics and chasubles, are long slender cloths that hang down almost to the ankles. They symbolize the yoke of the Lord: the priest's vocation as the servant of God. As the priest dons his garments before Mass, he kisses a representation of the cross at the center of the stole before placing it around his neck. Under the chasuble or dalmatic and stole, the priest or deacon wears an alb, a long white linen garment that symbolizes the purity of the priest's ceremonial function.

The style of the Medici vestment is typical of sixteenth-century liturgical stoles, which are larger toward the ends and carry decorative tassels. The simple motif, which adheres to the elongation of the garment, combines two of the instruments of the Passion: the rod with the sponge soaked in vinegar that was thrust in Christ's wound and the lance that had made the wound in his side. DDG

21. MANIPLE

1593–1600, GUASPARRI DI BARTOLOMEO PAPINI (DIED 1621)
AFTER CARTOON BY ALESSANDRO ALLORI (1535–1607)
TAPESTRY IN SILK WITH GILT-SILVER THREADS; 86 X 13 (33⅞ X 5⅛)
BIBLIOTECA APOSTOLICA VATICANA, MUSEO SACRO, 2728, 2733

The maniple, a short strip of cloth worn over the priest's left arm during Mass, is said to symbolize the ropes binding Christ's hands during his trial before Pontius Pilate. The vestment is stored folded to resemble the letter "I", and the stole is laid in an "H" shape, with the girdle (belt that holds the alb and stole) in an "S" shape. The three together form the letters "IHS": Christ's monogram in Hebrew, which is seen on other vestments and coverings for the Mass. The Vatican maniple is decorated simply with the ropes (flagella, scourge) used to whip Christ. The ends of the scourge splay elegantly with the enlargement of the ends of the maniple. The three maniples in the set were completed by 24 December 1600. DDG

22. CHALICE VEIL

1593–1600, GUASPARRI DI BARTOLOMEO PAPINI (DIED 1621)
AFTER CARTOON BY ALESSANDRO ALLORI (1535–1607)
TAPESTRY IN SILK WITH GILT-SILVER THREADS; 91 X 117 (35⅞ X 46⅛)
BIBLIOTECA APOSTOLICA VATICANA, MUSEO SACRO, 2774

The chalice used during the Eucharistic rite is carried to and from the altar by the priest before and after the celebration of the Mass. A veil covers the chalice until the Consecration of the Host and again after the Communion. More elaborate than most, the Vatican chalice veil has rings attached above and below the angels where rods were inserted to raise and lower the heavy material over the chalice.

The ornamentation of the chalice veil is more joyful in theme than the other vestments. Angels carrying censers and incense boats flank an elaborately held bowl of spring flowers. Above the bowl is the inscription "APPARVERVNT," which has been interpreted as the first part of a line from the Song of Solomon (2:12): *flores apparunt in terra nostra* (flowers appear on the earth). The Easter reference is clear: after Holy Week, the Resurrection of Christ will bring new life to the Earth. DDG

23. MISSAL COVER

1593–1600, GUASPARRI DI BARTOLOMEO PAPINI (DIED 1621)
AFTER CARTOON BY ALESSANDRO ALLORI (1535–1607)
TAPESTRY IN SILK WITH GILT-SILVER THREADS; 55.2 X 78.1 (21¾ X 30¾)
BIBLIOTECA APOSTOLICA VATICANA, MUSEO SACRO, 2771

The missal is the book with prayers and the liturgy of the seasons that the priest reads at the altar during Mass. In elaborate ceremonial churches such as the Sistine Chapel, these books would be covered with decorative, protective cloths. The subject on this missal cover is a crowned figure holding a scepter and a book with the image of the Holy Ghost in her left hand and a ciborium in the form of a temple with her right. In his book the *Iconologia* (1603), which codified attributes of allegorical figures, Cesare Ripa identified her as the Virgin (in blue), an allegory of the Church. Rays emanate from the ciborium (the vessel that contains the consecrated host). The temple symbolizes religion and wisdom as well as the Church. Appropriate for the chapel dedicated to her Assumption are other Marian references, which come from the Litany of Our Lady of Loreto, a prayer instituted in 1587 by Pope Sixtus V, one of Clement VIII's predecessors. The stars in the sky, the crown, and the scepter denote Mary as the Queen of Heaven and the numerous stars depict her as the Queen of All Saints. In addition, the temple and book she holds suggest she is also the seat of wisdom.

Allori was paid for the cartoons for the book covers in 1598. DDG

24. MISSAL COVER

1593–1600, GUASPARRI DI BARTOLOMEO PAPINI (DIED 1621)
AFTER CARTOON BY ALESSANDRO ALLORI (1535–1607)
TAPESTRY IN SILK WITH GILT-SILVER THREADS; 55.2 X 54 (21¾ X 21¼)
BIBLIOTECA APOSTOLICA VATICANA, MUSEO SACRO, 2770

The praying female figure embodies True and Certain Hope. Figures such as this were codified in Cesare Ripa's *Iconologia* (1603). The *Iconologia*, with illustrations and explanations of attributes for allegorical figures, became an easy reference tool for artists for the next 200 years. According to Ripa, True and Certain Hope should be represented by a woman wearing green, symbolizing the hope of abundance on the Earth, who keeps her hands folded in prayer while looking toward heaven. DDG

25. MISSAL COVER

1593–1600, GUASPARRI DI BARTOLOMEO PAPINI (DIED 1621)
AFTER CARTOON BY ALESSANDRO ALLORI (1535–1607)
TAPESTRY IN SILK WITH GILT-SILVER THREADS; 55.2 X 54 (21¾ X 21¼)
BIBLIOTECA APOSTOLICA VATICANA, MUSEO SACRO, 2772

Like the allegorical figure on the preceding missal cover, Christian Faith sits on a stool adorned with the Medici coat of arms. Unlike many of the other liturgical tapestries and vestments in this series, the coat of arms was not removed for insertion of either the Medici/Lorraine arms or the pontifical arms. Ripa described Christian Faith as a woman dressed in white, holding a chalice in one hand and a cross in the other. Here, she wears red and pink, indicating there was often room for artistic license in the representations of allegorical figures. DDG

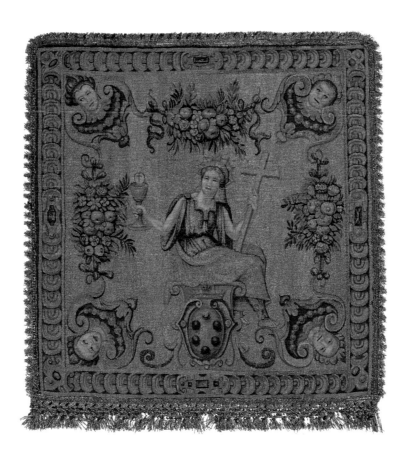

26. BURSE (CORPORAL CASE)

1593–1600, GUASPARRI DI BARTOLOMEO PAPINI (DIED 1621)
AFTER CARTOON BY ALESSANDRO ALLORI (1535–1607)
TAPESTRY IN SILK WITH GILT-SILVER THREADS; 52.1 X 52.1 (20½ X 20½)
BIBLIOTECA APOSTOLICA VATICANA, MUSEO SACRO, 2781

A burse is the square container for the corporal, the cloth that covers the Eucharist before the consecration. Appropriately, the representation here is of a wood cross and crown of thorns. From the cross grow bramble bushes, symbolic of Mary's purity, which fill the space and transform themselves into the decorative volutes and cherubim surrounding the square edges of the composition. DDG

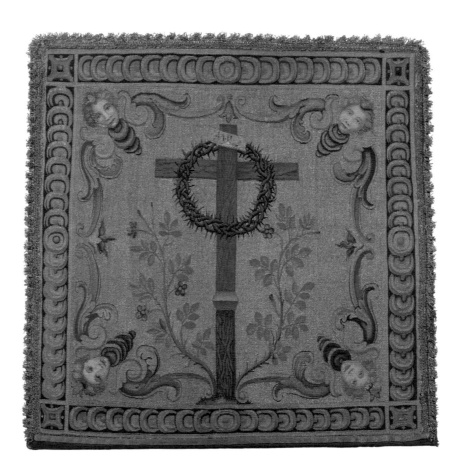

27. MORSE (CLASP)

1593–1600, GUASPARRI DI BARTOLOMEO PAPINI (DIED 1621)

AFTER CARTOON BY ALESSANDRO ALLORI (1535–1607)

TAPESTRY IN SILK WITH GILT-SILVER THREADS; 13 X 23.2 (5⅛ X 9⅛)

BIBLIOTECA APOSTOLICA VATICANA, MUSEO SACRO, 2782

A morse fastens the center of the cope worn by priests. Made of heavy fabric or metal, these clasps are decorated with scenes or symbols appropriate to the time of the liturgical year when they are worn. The Vatican morse depicts the bound hands of Christ, appropriate both to Holy Week and as a reiteration of the function of the clasp. DDG

Leo XI
*Alessandro
Ottaviano de'
Medici*
1605

Paul V
Camillo Borghese
1605–21

Gregory XV
Alessandro Ludovisi
1621–23

Urban VIII
Maffeo Barberini
1623–44

Innocent X
*Gian Battista
Pamphili*
1644–55

Alexander VII
Fabio Chigi
1655–67

Clement IX
Giulio Rospigliosi
1667–69

Clement X
Emilio Altieri
1670–76

Blessed Innocent XI
*Benedetto
Odescalchi*
1676–89

Alexander VIII
Pietro Ottoboni
1689–91

Innocent XII
Antonio Pignatelli
1691–1700

CARAVAGGIO, BERNINI, AND THE TRIUMPH
OF THE BAROQUE

THE ROMAN CATHOLIC CHURCH suffered from vast numbers of defections in the early sixteenth century. Much of northern Europe followed Martin Luther's lead after his critique of Church practices, the Ninety-Five Theses (1517), considered the original document of the Reformation. The Church lost England over Henry VIII's autocratic decision to divorce. In 1527 Rome, always thought to be inviolate, was sacked by the mercenary soldiers of Charles V. These events, as well as criticism of the profligacy of the Church, awakened an urgent need to reform.

After years of negotiation to call a Church council, Pope Paul III convened the Council of Trent in 1542. The council, which spoke to the Protestant heresies and its own internal reform, lasted twenty years. When it ended in 1563 after twenty-five sessions, numerous decrees were declared. Although the only mention of art in these decrees was minimal and general, the need for art to serve the goals of the Church was well known and often discussed. The Church wished to reach Catholics with the message of faith and salvation and keep from losing more of its members to Protestantism. Rules for both clergy and their parishioners became stricter and, concurrently, the message of faith became clearer.

In the third quarter of the sixteenth century, Italian art had become arcane and convoluted. Often only the artistic patrons and their literary advisors could understand the principal themes, hidden by virtuoso embellishment and extraneous decoration. At the end of the century, artists understood the need for change and the return to a more direct and understandable subject matter. Painters such as Caravaggio represented naturalistic and idealized figures and produced paintings with subjects and forms that related to everyday life, explaining theological tenets in an understandable way. Apocryphal and legendary tales, always popular, were expunged from the artistic repertoire.

By the 1620s the Church had succeeded in keeping and once more expanding its membership with the institution of large confraternities and missionary orders. The great basilica of Saint Peter's had been completed, too, and Rome had become the diplomatic and artistic center of Europe. The time had arrived to celebrate the triumph of Catholicism. Artists, led by Bernini, began to decorate the new basilica and the numerous local churches being built in the city. Architects embellished churches in gold; painters created heavenly triumphs with choirs of angels in billowing clouds. Christ, the Virgin, and saints looked down from cupolas as they

were carried to heaven. At the same time the spirituality of the reformed Church was not forgotten. Devotional pictures encouraged the faithful to follow the path of Christ and offer up their earthly sufferings. As often, the emphasis was on the rewards of salvation and the triumph of the faithful in heaven.

The objects in this section reflect the various facets of baroque art. Caravaggio's *Entombment of Christ* exemplifies the naturalistic tendencies and spiritual resolve of baroque art. The bust of Pope Urban VIII and the terracotta models for his tomb reflect the power of the papacy and of one man who directed the artistic changes in Catholic Rome. DDG

28. THE ENTOMBMENT OF CHRIST

1602–4, CARAVAGGIO [MICHELANGELO MERISI DA CARAVAGGIO]
(ITALIAN, 1571–1610). OIL ON CANVAS
300 X 203 (118⅛ X 79⅞)
PINACOTECA VATICANA, 386

Caravaggio is probably the best-known Italian artist of the seventeenth century today. His name is synonymous with realism, drama, bohemianism, and violence. Caravaggio grew up in Lombardy and settled in Rome in 1592, where within a few years he became one of the most popular and controversial artists of the period. His enigmatic half-length figures with naturalistic still-life elements set against simple backgrounds and his card players set in raking light and shade became the model for these genres throughout Europe.

Seventeenth-century critics debated the significance of Caravaggio's style. Some believed his dismissal of idealistic figures ran counter to art's mission, especially in religious paintings. Some of these paintings were rejected by his ecclesiastical patrons for a perceived vulgarity and lack of decorum in the insertion of ordinary and low-life models. Caravaggio's patrons also criticized his profligate lifestyle and frequent run-ins with the authorities. Indeed, the artist was forced to flee Rome in 1606 after killing a man over a bet on a tennis match.

Caravaggio spent his remaining years in Naples, Sicily, and Malta, painting increasingly more loosely brushed, dark, emotional, and moody pictures, such as Cleveland's *Martyrdom of Saint Andrew* (c. 1607), and again he was frequently in trouble with the law. In 1610 while returning to Rome to be pardoned for his earlier crime, Caravaggio died precipitously of fever after arriving at Porto Ercole.

The Entombment of Christ evoked praise even before it was installed in the Vittrici Chapel in the Chiesa Nuova in Rome in 1604. A document of 1602, written while the picture was in progress, called it Caravaggio's masterpiece. Numerous copies of the picture exist, including one of the earliest (c. 1608), by Peter Paul Rubens (1577–1640). The artist and writer Giovanni Baglione, who was once involved in a lawsuit against Caravaggio, admitted that it was considered the artist's greatest work. Documents indicate that the picture was already begun early in 1602, probably having been commissioned in late 1601 by a nephew of Pietro Vittrici, who had purchased the chapel in 1577. It remained in the Chiesa Nuova until it was taken by Napoleon's armies to Paris in 1797 and replaced by a copy by Vincenzo Camuccini (1771–1844). The painting returned to Rome in 1817 and went directly to the Vatican Museums.

That the picture arouses intense reactions and praise from its viewers is understandable. The life-size figures address the audience directly. Nicodemus and John almost press Christ's body forward as they place him in the tomb, and the three Marys express genuine human emotions. The Virgin Mary (realistically depicted as an older mother) holds out her

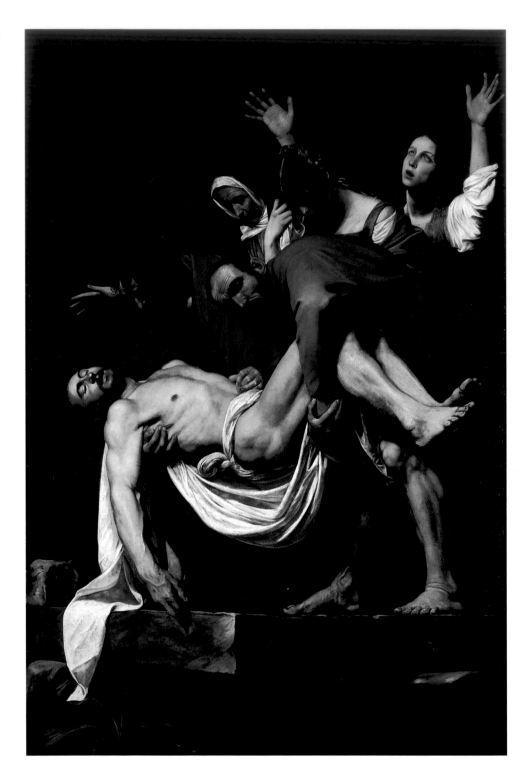

arms in protection and grief; Mary Magdalene weeps quietly; and Mary Cleophas invokes the heavens. The black background acts as a theatrical curtain to this dramatic tableau. Blood drips from Christ's wound, and his closed eyes, open mouth, and pale body express his recent death. The drama is heightened by the chiaroscuro (sharply contrasted lights and darks) for which Caravaggio was famous. While death and grief are foremost elements of the life-like subject, placing the scene within the viewer's space and emotions, the monumentality and sculptural beauty of the forms, inspired by Caravaggio's Renaissance predecessors Raphael and Michelangelo, remove it from the everyday to the eternal.

The nature of the subject of the painting has been debated. The picture has been called a Deposition, but the cross is not in evidence. If it is instead an Entombment, why then is the Virgin Mary present when the Gospels indicate that only Nicodemus, Mary Magdalene, and Mary Cleophas were there? The Virgin appears here because of the exigencies of the commission. The chapels of the Chiesa Nuova, planned by Saint Philip Neri, were designed with altarpieces to elicit meditation on the Mysteries of the Rosary. Caravaggio's *Entombment* replaced an earlier Pietà in the chapel, and Mary's outstretched arms cleverly hint that the picture also represents the Pietà, the subject of the chapel's dedication. Some scholars suggest that Christ is being placed on the stone of unction, a symbol of his role as the cornerstone of the new church, which was then used to seal the tomb. Others emphasize that he is wrapped in the holy shroud, for which veneration was especially popular at this time. The inclusion of the realistic still life growing from the tomb is symbolic, too. The yew tree may come from Isaiah 53:2 (For he shall grow up before him as a tender plant, and as a root from dry ground) and refer to Christ's appearance on Earth. Scholars also suggest that the fig may be a resurrection symbol implied in parables by Luke (13:6–9 and 21:29–31).

Despite the necessary symbolic aspects of the picture, the *Entombment* maintains an immediacy that accounts for its popularity as a devotional work. Caravaggio's illusionism of real, solid figures in space was accomplished by his innovative technique. He did not make long preparations of compositional drawings for his paintings but drew directly on the canvas using posed models as he painted. He probably also posed groups of figures together in various tableaux because his pictures have the aspect of a play unfolding on stage. He then lit his figures with strong light from above, giving them a realistic three-dimensionality; his dark grounds accentuate the contrasts. These revolutionary aspects of his style are apparent in the *Entombment* and help make it Caravaggio's masterpiece of religious drama. DDG

REFERENCES

Maurizio Marini, *Caravaggio: Michelangelo Merisi da Caravaggio "pictor praestantissimus"* (Rome, 1987), 461–64, cat. no. 51 (with critical discussion of bibliography); Sheldon Grossman, *Caravaggio "The Deposition" from the Vatican Collections*, exh. cat., National Gallery of Art (Washington, 1984); Very Reverend Val A. McInnes, O.P., ed., *Treasures of the Vatican*, exh. cat., Vatican Pavilion at 1984 Louisiana World Exposition (New Orleans, 1984), 58–60, cat. no. 50; Fabrizio Mancinelli in *Vatican Collections*, 160–63, cat. no. 85; Alessandro Zuccari, "La cappella delle 'Pietà' alla Chiesa Nuova e i committenti del Caravaggio," *Storia dell'arte* 47 (1983), 53–56 (for the commission of the chapel); Georgia Wright, "Caravaggio's *Entombment* Considered 'in Situ,'" *Art Bulletin* 60 (1978), 35–42; Mary Ann Graeve, "The Stone of Unction in Caravaggio's Painting for the Chiesa Nuova," *Art Bulletin* 40 (1958), 223–38; Giovanni Baglione, *Le vite de' pittori, scultori, architetti, ed intagliatori, dal pontificato di Gregoria XIII del 1572* (Rome, 1642), 137.

29. RELIQUARY OF THE VOLTO SANTO (MANDILION OF EDESSA)

C. 400–600, FRAME BY FRANCESCO COMI, 1623. RELIC: PAINTING ON CLOTH; 28 X 19 (11 X 7½)
FRAME: PARTIALLY GILT CAST SILVER, EMBOSSED AND CHASED, WITH ENAMEL, PEARLS, AND
PRECIOUS STONES. 65 X 45 (25⅝ X 17¾). TESORO DELLA SAGRESTIA PONTIFICIA

This relic of the Volto Santo (Holy Face), framed elaborately in the baroque period, is the oldest known image in Rome that was venerated as a portrait of Christ. It is one of several images that have been associated with a legend about Abgar (4 BC–AD 50), the king of Edessa in Asia Minor: after hearing Christ preach, Abgar commanded his secretary and painter Ananias to bring him a likeness of Christ. Because no mortal could reproduce Christ's image, the resultant portrait had to have been a miraculous transference to the cloth, an *archeiropoietos* (not made by human hands). The cloth was called a *mandilion*, the Greek word for "handkerchief." Two later versions of the image are known: a tenth-century triptych once at Sinai and now lost and a thirteenth-century painting on wood conserved at San Bartolomeo degli Armeni in Genoa. The latter appears to be a direct copy of the Vatican image. The *Mandilion of Edessa* is first recorded in the fourth century. By 544 its capacity to perform miracles was evidenced by its use to ward off the siege of Edessa by Persian troops. Its power and fame remained high in the following centuries and, in fact, its existence was used as an argument in favor of the veneration of icons during the iconoclastic controversy in the eighth and ninth centuries. The icon was taken to Constantinople in the tenth century and sold to the Venetians in the thirteenth century.

This relic should not be confused with another image of Christ, the image of the Redeemer on the altar of the chapel of Saint Lawrence at the Lateran. Thought by medieval Romans to have been painted by the angels, this icon was first recorded c. 750 during the papacy of Stephen II. A third miraculous image of Christ, recorded in Rome in the 1300s, also needs mention: the Veil of Veronica (the sudarium). According to the legend that grew up in the Western Church in the Middle Ages, Christ had wiped his face on a cloth given to him by a woman named Veronica. The tale remained popular even after it was known that the name "Veronica" was a misreading of *vera icon* (true icon).

The Vatican Volto Santo was recorded in Rome around 1200. By 1587 it resided in the monastery of San Silvestro in Capite. While the relic of the sudarium (also in the Vatican collections) was popular and copied by artists in the early seventeenth century, the precious *Mandilion of Edessa* was guarded in secrecy and shown only rarely to special visitors. Nor were indulgences attached to it. Yet it was one of the most venerated relics in Rome for centuries. It remained at San Silvestro until 1870, when it was transferred to the Vatican by Pius IX in fear of looting after the dissolution of the papal states. The date of the symmetrical, hieratic, and

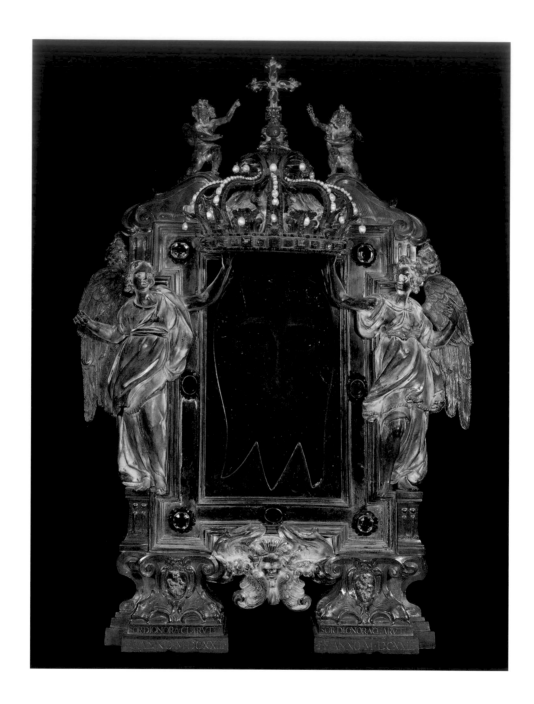

haunting image must be early and Eastern, possibly Edessian, in origin. The thick varnish coating over the fleeting image, however, makes study of the image difficult.

The frame by Roman goldsmith Francesco Comi was commissioned by Sister Dionora Chiarucci in 1622 and finished in 1623, commemorated by an inscription and date on the base. Sister Dionora commissioned other works in San Silvestro in Capite, a monastery of the nuns of Saint Clare. The intricacy, precious materials, and detail of the frame, architectonic in its monumentality, speak of the venerability of the relic it contains. The simple rectangular frame is embellished with volutes and masks typical of the architecture of the period, and the animated angels and cherubs reflect the influence of Bernini, who was working in Saint Peter's at precisely the same moment. Its embellishment exemplifies the importance placed on the ancient relics of the Church, extremely rare and greatly appreciated in counter-reformatory Rome. DDG

REFERENCES

Morello, *Vatican Treasures*, 154–55, cat. no. 33; Carlo Bertelli in *Splendori di Bisanzio*, exh. cat. (Milan, 1990), 122, under cat. no. 46; Carlo Bertelli, "Storia e vicende dell'Imagine Edessena di San Silvestro in Capite a Roma," *Paragone* 19, no. 217/37 (1968), 4–33; Ilaria Toesca, "La cornice dell'Immagine Edessena di San Silvestro in Capite a Roma," *Paragone* 19, no. 217/37 (1968), 33–37.

30. CHARITY WITH FOUR CHILDREN

C. 1627–28, GIAN LORENZO BERNINI (ITALIAN, 1598–1680)
TERRACOTTA, WITH TRACES OF GILDING; H. 39 (15⅜)
BIBLIOTECA APOSTOLICA VATICANA, MUSEO SACRO, 2423

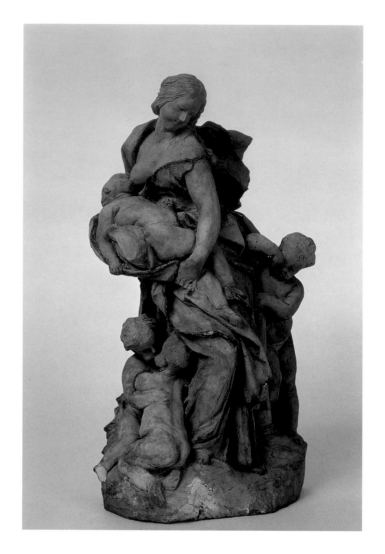

A child prodigy, Gian Lorenzo Bernini trained in the studio of his father, Pietro Bernini (1562–1629). Scholars agree on his importance and supremacy to seventeenth-century sculpture in Europe. His works, which often combine different materials and media, reflect a technical mastery not seen since Michelangelo and the ancients. Bernini's sculpture had the actual feeling of flesh; he also imparted a movement, naturalism, emotion, and drama to his works not known previously. A man of incredible energy, innovation, and devout spirituality, he was equally proficient as an architect, painter, urban planner, and dramatist. He can be credited with the transformation of high baroque Rome. Throughout his long and productive life he worked for eight popes in Rome and traveled to Paris in 1665 to work for King Louis XIV. He wielded vast power as architect of Saint Peter's from 1629 to 1646. Because of his many commissions in the papal city he had a large and active workshop to execute his designs, which he followed closely to fruition.

31. CHARITY WITH TWO CHILDREN

C. 1631–34, GIAN LORENZO BERNINI (ITALIAN, 1598–1680)
TERRACOTTA; H. 41.6 (16⅜)
BIBLIOTECA APOSTOLICA VATICANA, MUSEO SACRO, 2422

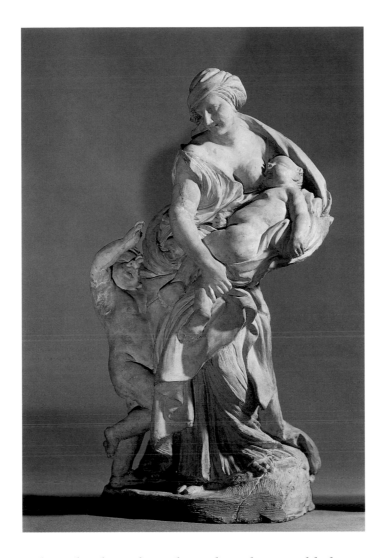

The papal tombs that adorn the aisles (above and below ground) of Saint Peter's basilica were commissioned mostly during the lifetimes of the pontiffs as eternal monuments to their reigns. Often, as in the case of Michelangelo's monument for Julius II, these commissions lasted the entire reign of the pope and beyond his death. Bernini began Urban VIII's monument, to be placed in a niche on the right of the apse, in 1627. It was completed in 1647, three years after Urban's death. Fortunately, documents, drawings, and these models help us follow Urban and Bernini's concept for the tomb. Bernini envisioned the tomb to be a triangular composition of monumental simplicity. A large seated bronze figure of the pope, dressed in splendid papal vestments and wearing the papal tiara, raises his right hand in blessing. On a lower register the mourning figures in marble of Charity, at left, and Justice, at right (two virtues for which Urban wished to be known), flank and lean against the longitudinal sepulcher. On the sepulcher the personification of death in the form

Bernini's tomb of
Pope Urban VIII as
it stands in Saint
Peter's

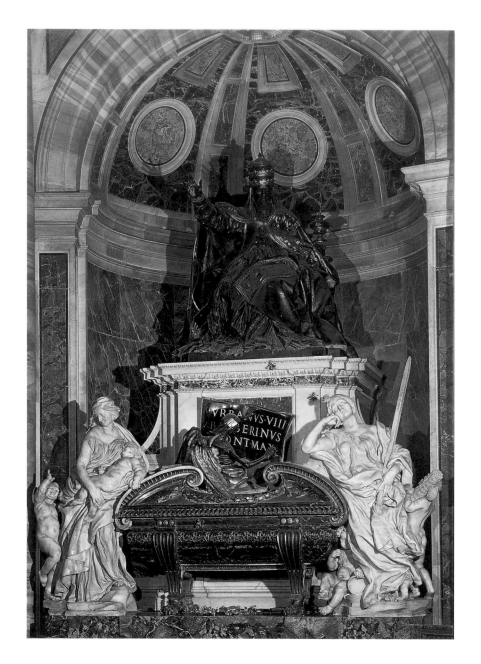

of a skeleton inscribes Urban's name in an open book. The tomb vibrates
with different, contrasting materials: gilt-bronze, bronze, and white and
colored marbles give a richness to the subtle simplicity of the composi-
tion. Bernini conceived his tomb to complement the earlier tomb of Paul
III (built 1549–75), which was moved to face this monument. Although
both tombs represent seated popes with allegories, Bernini's is far more
active with heightened naturalism, volume, and movement given the fig-
ures. The informality of the poses coupled with the drama and emotion
of figures in a simple format became the model for papal future tombs.

The two terracottas for Charity are the only models known that relate to the tomb and in their differences explain the progress from the conception to the completion of the monument. The model of Charity with four children must date from early in the project, probably c. 1627–28, when Bernini considered a violently twisting, almost fleeing, figure with one child at her breast, a second, crying infant tugging at her robes, and two other babies embracing at lower right. By 1630, however, Bernini was not sure whether he wanted to represent Charity with two or three children. A second model for the project dates to c. 1631–34 and shows Charity with two children. By 1631 the statue of Urban was probably completed and the marble block for Charity purchased. The block was trimmed in 1634, giving a terminus date to the terracotta of *Charity with Two Children.* The project stopped for some years, but in 1639 Bernini was working on the marble block for Charity. Bernini did not begin the figure of Justice until at least 1644. The cessation of activity on the tomb may have been because of his other commissions for the pope, including the baldacchino and the statue of Saint Longinus for the basilica of Saint Peter's.

The finished allegory renders the figure with only two children, like that of the second Vatican model. Different from the earlier model, the *Charity with Two Children* is simpler in concept, less violent in contortion, and accords better with the sepulcher it adjoins. Although still very much in active movement, Charity, without the two children at her feet, rests comfortably on the tomb. The subtle differences from the finished marble are found in the less-attenuated figure of Charity, variations in the folds of drapery, and the pose of the baby standing at the left.

Evidence of Bernini's direct relationship with these models accentuates their liveliness. The clay was worked with both modeling tools and the sculptor's fingers. The striations on the hair, drapery, and ground, and the deep undercutting within the drapery create active contrast and movement of light and shadow. The backs are unfinished as the figure was meant to be seen only from one side. Characteristic of Bernini's handling is the soft suppleness of the figure and the realistic rendering and differentiation of draperies and flesh, apparent also in the finished marble. Bernini thought of his models (known as *bozzetti*) as creative sketches to be used as general, not precise, guides to the creation of a sculpture.

Both models portray Charity with her left breast uncovered suckling a child. The marble followed this natural form for the allegorical figure, but her breast was soon prudently covered by stucco drapery, probably even in the seventeenth century. The terracottas, which remained in the Chigi collection until 1923, were conserved in 1980–81 when a dark

coat of paint, probably added in the nineteenth century to give an impression of bronze, was removed. Water gilding underneath the paint, possibly also from the nineteenth century, on the *Charity with Four Children* remains.

Recent questions about the authenticity of the *Charity with Four Children* have arisen. The figure is livelier in contrapposto, has less differentiation of texture, and appears less flesh-like than the *Charity with Two Children.* Moreover, there are only two children apparent in an early workshop drawing for the tomb. The earlier dating for the terracotta and the Chigi provenance would seem to argue in its favor as a work by Bernini; however, the popularity of his images spawned many imitations.
DDG

REFERENCES
Catherine Johnston, Gyde Vanier Shepherd, and Marc Worsdale, *Vatican Spendour: Masterpieces of Baroque Art*, exh. cat., National Gallery of Canada (Ottawa, 1986), 82–85, cat. nos. 17–18; Olga Raggio in Morello, *Vatican Collections*, 85–86, cat. nos. 27–28; Maria Teresa De Lotto in *Bernini in Vaticano*, exh. cat., Braccio di Carlo Magno (Vatican City, 1981), 108–9; Irving Lavin et al., *Drawings by Gianlorenzo Bernini from the Museum der Bildenden Künst Leipzig, German Democratic Republic*, exh. cat., Art Museum, Princeton University (Princeton, 1981), 62–71; Rudolf Wittkower, *Gian Lorenzo Bernini: The Sculptor of the Roman Baroque*, 2nd ed. (London, 1966), 198–99, cat. no. 30.

32. POPE URBAN VIII

1632, GIAN LORENZO BERNINI (ITALIAN, 1598–1680)
BRONZE; 100 X 73 X 41 (39⅜ X 28¾ X 16⅛), WITH BASE
BIBLIOTECA APOSTOLICA VATICANA, MUSEO SACRO, 2427

This bust of Bernini's friend Maffeo Barberini is one of fourteen documented portrait busts of him by the sculptor in bronze and marble after Barberini became Pope Urban VIII. Urban was a handsome, intelligent, literary pope who was educated as a jurist but wrote and published poetry. With his family, whom he shamelessly promoted during his papacy, he can be credited with the patronage that transformed Rome into the seat of the high baroque style and the international crossroads of artistic taste. Unfortunately, in his enthusiasm, the marble and bronze to build some of his architectural projects were stripped from ancient monuments, including the Colosseum and the Pantheon. This earned the Barberini family the contemporary barb "what the barbarians didn't do, the Barberini did."

It was also to the enlightened patronage of Urban VIII that Bernini developed the interior space of Saint Peter's. For him, Bernini sculpted the monumental baldacchino over the tomb of Saint Peter (1624–33), the crossing with pillars, balconies, and monumental sculptures (1629–30), and Urban VIII's tomb (1628–1647). For succeeding popes, he created the *cattedra* (throne) of Saint Peter on the high altar (1655–65), the statue of Constantine on horseback (1662–70), the Scala Regia (ceremonial staircase to the Vatican palace) (1663–66), and the grandiose exterior piazza with its welcoming colonnaded arms (1656–67). For Urban himself Bernini created the church and sculpture of Saint Bibiana (1624–26), the Triton fountain in the Piazza Barberini (1642–43), and many portrait busts of members of the Barberini family.

The bronze bust exhibited here was made for the Barberini library, the largest after that of the Vatican. It remained in the Palazzo Barberini until 1902, when it was acquired by the Vatican with the contents of the library and the wooden niche for the sculpture. The bronze is a replica of the marble bust of Urban VIII formerly in the Barberini collection and now in the Galleria Nazionale d'Arte Antica, housed in the Palazzo Barberini. Tooling from the terracotta model, noted in the inventory of Bernini's heirs in 1706, used for both the marble and the bronze, is visible on the back of the bust. Scholarly debate on the dating of the various Bernini busts of Urban is often based on the differences in Urban's aging features and the trimming of his well-kept beard. It is certain, however, that the Barberini marble dates to 1632 based on the similarity of the features with a portrait engraving of Urban by Claude Mellan of 1631 and Lelio Guidiccioni's description of the bust in a letter of 1632. In praising the life-like quality of the bust Guidiccioni stated, "The bust has no arms, but a slight motion of the right shoulder and a lifting of his *mozzetta* [short

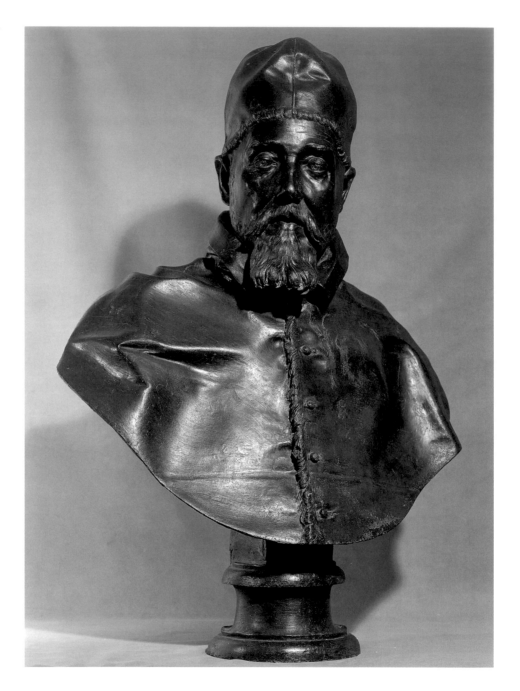

velvet cape], in addition to the inclination of the head . . . clearly indicates the action of signaling with the arm to someone to get up." The pope is "thoughtful yet serene, suave yet full of majesty, witty yet serious: he smiles and is venerable." The description is accurate of what we know of Urban VIII's personality. The bronze replica is also datable to 1632: that year a pedestal for the bust was brought to the Palazzo Barberini. In 1633 Giovanni Battista Soria was commissioned to make the wooden niche for the bust. The bust was mentioned in situ in the Barberini library in a description of 1642. There is another bronze replica of the marble bust, inferior to this one, in the Palazzo Comunale in Camerino, near Rome.

Urban VIII wears the papal mozzetta, trimmed in ermine and the matching velvet and ermine *camaura* (papal cap) worn on informal occasions. In both the marble and bronze busts a horizontal crease toward the bottom of the mozzetta shows where the material had been folded. This adds to the immediacy and naturalism of the representation, a quality for which Bernini is praised. Bernini is responsible for the invention of this type of informal portrait bust, which has been emulated ever since. DDG

REFERENCES
Johnston, Shepherd, Worsdale, *Vatican Splendour*, 78–79, cat. no. 15; Morello, *Vatican Collections*, 84, cat. no. 26; De Lotto, *Bernini in Vaticano*, 114, cat. no. 94; Rudolf Wittkower, "A New Bust of Pope Urban VIII by Bernini," *Burlington Magazine* 111, no. 790 (1969), 60–64; Wittkower, *Bernini*, 184–88.

1. *The Cross of Justin II, 565–78*
Constantinople
Gilt silver and precious stones
40 x 32.4 (15¾ x 12¾)
Treasury of Saint Peter's

2. *Diptych with Portraits of Peter and Paul,*
6th–7th century
Rome (?)
Encaustic on wood
Two panels, each 8.6 x 5.7 (3⅜ x 2¼)
Biblioteca Apostolica Vaticana, Museo Sacro,
1911

3. *Reliquary Box with Stones from the Holy*
Sites of Palestine, 6th–7th century
Palestine
Wood, tempera, and gold leaf
24.1 x 18.4 x 4.1 (9½ x 7¼ x 1⅝)
Biblioteca Apostolica Vaticana, Museo Sacro,
1883a–b

4. *Reliquary of the True Cross (The Cross of*
Pope Paschal I), 817–24
Palestine or Rome (?)
Gold and cloisonné enamel
27 x 18 x 3.5 (10⅝ x 7 x 1⅜)
Biblioteca Apostolica Vaticana, Museo Sacro,
1881

5. *Casket for the Reliquary Cross of Pope*
Paschal I, 817–24
Rome
Partially gilt silver
30 x 19.7 x 6.2 (11⅞ x 7¾ x 2½)
Biblioteca Apostolica Vaticana, Museo Sacro,
1888

6. *Casket for a Cross-Shaped Reliquary,*
817–24
Rome
Partially gilt silver, with niello
29.5 x 25 x 9.8–10 (11⅝ x 9⅞ x 3⅞–4)
Biblioteca Apostolica Vaticana, Museo Sacro,
985

7. *Hunting Textile,* 5th–8th century
Eastern Mediterranean (Syria? Egypt?)
Silk, compound twill
42.4 x 34.7 (16¾ x 13⅝)
Biblioteca Apostolica Vaticana, Museo Sacro,
1250

8. *"Samson" Textile,* 6th–8th century
Eastern Mediterranean (Syria? Egypt?)
Silk, compound twill
19.7 x 16.4 (7¾ x 6½)
Biblioteca Apostolica Vaticana, Museo Sacro,
1247

9. *The Christmas Missal of Pope Alexander*
VI, 1492–94
Fra Antonio da Monza and collaborators
(Italian, Milan, active in Rome 1492–1503)
Ink, tempera, and gold on parchment, 69
leaves
46.5 x 32.4 (18⅜ x 12¾)
Biblioteca Apostolica Vaticana, MS Borg.
Lat. 425

10. *Antiphonary of Pope Leo X,* c. 1520(?)
Rome
Ink, tempera, and gold on parchment, 93
leaves
57.5 x 41 (22⅝ x 16⅛)
Biblioteca Apostolica Vaticana, MS Cappella
Sistina 10

11. *Constitutions of the Sistine Chapel,* 1545
Vincent Raymond (French, active in Rome at
the papal court c. 1513–57)
Ink, tempera, and liquid gold on parchment,
60 leaves
36.5 x 25.5 (14⅜ x 10⅛)
Biblioteca Apostolica Vaticana, MS Cappella
Sistina 611

12. *The Construction of Saint Peter's Viewed*
from the Southwest, after May 1545
Anonymous (Flemish)
Pen and brown and red ink
29.9 x 43.8 (11¾ x 17¼)
Biblioteca Apostolica Vaticana, Disegni
Ashby, 330

13. *Façade of Saint Peter's Basilica,* 1548
Antonio Labacco (born c. 1495), after
Antonio da Sangallo the Younger (1483–1546)
Engraving
60 x 45 (23⅝ x 17¾)
Biblioteca Apostolica Vaticana, St. Barb. XI
13a, f. 17

14. *Letter Concerning Work on Saint Peter's*
Basilica, c. 1550–53(?)
Michelangelo Buonarotti (Italian, 1475–1564)
Brown ink on paper
22.5 x 20.5 (8⅞ x 8⅛)
Biblioteca Apostolica Vaticana, Chig. H II 22,
f. 25

The Vestments of Pope Clement VIII
Guasparri di Bartolomeo Papini (died 1621),
after cartoons by Alessandro Allori (1535–
1607)
Tapestry in silk with gilt-silver threads

15. *Altar Frontal,* 1593–95
101.9 x 358.5 (40⅛ x 141⅛)
Biblioteca Apostolica Vaticana, Museo Sacro,
2780

16. *Cope,* 1593–1600
151.3 x 319.1 (59½ x 125⅝)
Biblioteca Apostolica Vaticana, Museo Sacro,
2773

17. *Chasuble,* 1593–1600
140 x 101.9 (55⅛ x 40⅛)
Biblioteca Apostolica Vaticana, Museo Sacro,
2769, 2730

18. *Dalmatic,* 1593–1600
135.3 x 146.1 (53¼ x 57½)
Biblioteca Apostolica Vaticana, Museo Sacro,
2777, 2778

19. *Dalmatic,* 1593–1600
134 x 147 (52¾ x 57⅞)
Biblioteca Apostolica Vaticana, Museo Sacro,
2727, 2731

20. *Stole,* 1593–1600
231.1 x 13 (91 x 5⅛)
Biblioteca Apostolica Vaticana, Museo Sacro,
2776 a–b

21. *Maniple*, 1593–1600
36 x 13 (33⅞ x 5⅛)
Biblioteca Apostolica Vaticana, Museo Sacro,
2728, 2733

22. *Chalice Veil*, 1593–1600
91 x 117 (35⅞ x 46⅛)
Biblioteca Apostolica Vaticana, Museo Sacro,
2774

23. *Missal Cover*, 1593–1600
55.2 x 78.1 (21¾ x 30¾)
Biblioteca Apostolica Vaticana, Museo Sacro,
2771

24. *Missal Cover*, 1593–1600
55.2 x 54 (21¾ x 21¼)
Biblioteca Apostolica Vaticana, Museo Sacro,
2770

25. *Missal Cover*, 1593–1600
55.2 x 54 (21¾ x 21¼)
Biblioteca Apostolica Vaticana, Museo Sacro,
2772

26. *Burse (Corporal Case)*, 1593–1600
52.1 x 52.1 (20½ x 20½)
Biblioteca Apostolica Vaticana, Museo Sacro,
2781

27. *Morse (Clasp)*, 1593–1600
13 x 23.2 (5⅛ x 9⅛)
Biblioteca Apostolica Vaticana, Museo Sacro,
2782

28. *The Entombment of Christ*, 1602–4
Caravaggio [Michelangelo Merisi da
Caravaggio] (Italian, 1571–1610)
Oil on canvas
300 x 203 (118⅛ x 79⅞)
Pinacoteca Vaticana, 386

29. *Reliquary of the Volto Santo (Mandilion
of Edessa)*, c. 400–600
Frame by Francesco Comi, 1623
Relic: painting on cloth; frame: partially gilt
cast silver, embossed and chased, with
enamel, pearls, and precious stones
Relic: 28 x 19 (11 x 7½); frame: 65 x 45 (25⅝
x 17¾)
Tesoro della Sagrestia Pontificia

30. *Charity with Four Children*, c. 1627–28
Gian Lorenzo Bernini (Italian, 1598–1680)
Terracotta, with traces of gilding
H. 39 (15⅜)
Biblioteca Apostolica Vaticana, Museo Sacro,
2423

31. *Charity with Two Children*, c. 1631–34
Gian Lorenzo Bernini (Italian, 1598–1680)
Terracotta
H. 41.6 (16⅜)
Biblioteca Apostolica Vaticana, Museo Sacro,
2422

32. *Pope Urban VIII*, 1632
Gian Lorenzo Bernini (Italian, 1598–1680)
Bronze
100 x 73 x 41 (39⅜ x 28¾ x 16⅛), with base
Biblioteca Apostolica Vaticana, Museo Sacro,
2427

33. *Front Cover of a Gospel Book with
Scenes from the Infancy of Christ and Bear-
ing the Arms of Cardinal Jean La Balue
(1421–1491)*, c. 1467–68
Italy, Florence
Nielloed silver plaques within gilt-silver
borders
41.6 x 29.5 x 1.6 (16⅜ x 11⅝ x ⅝)
The Cleveland Museum of Art, J. H. Wade
Fund 1952.109

34. *Pope Paul II*, 1468
Cristoforo di Geremia (Italian, b. Mantua,
active in Rome 1456–76)
Bronze medal, medium brown lacquer
4.2 x 3.7 (1¾ x 1½)
The Cleveland Museum of Art, Gift of
Kelvin Smith in memory of Candle Kelly
1984.1

Obverse: sitter in profile bust length with
the inscription: PABLO VANITY PAPER II ITALICS
PACES FVNDATORE ROMA; reverse: Barbo
arms, papal keys, and tiara

35. *Study for the Nude Youth over the
Prophet Daniel* (recto), *Various Studies of
the Human Figure* (verso), c. 1510
Michelangelo Buonarotti (Italian, 1475–
1564)
Black and red chalk (recto), red chalk with
traces of white heightening (verso)
34.3 x 24.3 (13½ x 9⅝)
The Cleveland Museum of Art, Gift in
memory of Henry G. Dalton by his nephews
George S. Kendrick and Harry D. Kendrick
1940.465

36. *Baptism of Christ*, designed 1645–46,
fabricated 1650–55
Alessandro Algardi (Italian, 1602–1654)
Bronze
62.3 x 45.7 (24½ x 18)
The Cleveland Museum of Art, Andrew R.
and Martha Holden Jennings Fund 1965.471

37. *Pope Innocent X*, designed 1647–48, fab-
ricated 1650–1700
Alessandro Algardi (Italian, 1602–1654)
Bronze
H. 78.1 (30¾)
The Cleveland Museum of Art, Gift of
Rosenberg & Steibel, Inc., in honor of
William Mathewson Milliken 1957.496

38. *The Risen Christ*, 1673–74
Gian Lorenzo Bernini (Italian, 1598–1680)
Bronze
H. 44 (17⅜)
The Walters Art Gallery, Baltimore, 54.2281

39. *Interior of St. Peter's, Rome*, 1731
Giovanni Paolo Panini (Italian, 1691–1765)
Oil on canvas
145.2 x 227.5 (57¼ x 89⅝)
Saint Louis Art Museum, museum purchase,
7:1946